How To Get Into
The Business Of
Photography

by Victor Kelley

An ETC Publication

Library of Congress in Publication Data

Kelley, Victor E 1935-
 How to get into the business of photography.

Includes index.
 1. Photography, Commercial. 1. Title.
TR690.K34 770'.232 78-31195
ISBN 0-88280-067-1 $9.95

Published by ETC Publications
 Palm Springs
 California 92263

Contents

Foreword

The reader will discover as he meanders through the pages of the book that the advice and suggestions offered are directed more to the photographer considering self-employment than to the individual just looking for employment in the field. The reason for this is (a) there is more money in it for the highly motivated, (b) it allows the photographer the freedom to practice the career he's dreamed of, and (c) the mechanics of just how to go about it confounds most people and presents the biggest obstacle in getting started.

There are thousands of professional photographers working today who would like to own their own business, but simply don't know how to go about it. Similarly, there are millions of amateur photographers who have a desire to get into the business, but just don't know how to begin. This book will provide such persons with information and guidance to help achieve those goals. For those photographers who already own their businesses, this book will offer valuable and timely advice in reviewing methods to increase their incomes and expand their trade.

The availability of fast black and white and color film, plus the increasing numbers of processing houses has made the trade more attractive to young people lately. The belief to many is that as long as they know how to expose film and have an eye for composition and lighting, they are designed for monumental success in the business. This kind of approach is inherently fallacious because, like any other trade, if one is technically poor in basics, he will never be able to master an art.

Granted, it would be a fabulous career if a photographer did nothing but expose film and have his processing house magically come up with the images he tried to capture, even down to the last detail. Some big city photographers, especially magazine cameramen, shoot in this manner. And their work is outstanding. But behind just about every one of these photographers is a solid foundation of technical expertise that they can conjure up to easily solve any heady graphic problems they come across.

In surveying photography as a career, the aspiring cameraman should try to realistically evaluate his chances and desires to be that certain kind of photographer that he set his sights on. He should judge his own ambition as to the amount of effort and sacrifice he is willing to expend to reach his goal.

Regardless of how crowded a profession is with young hopefuls trying to reach the inner chambers, the world of photography, like any other business, will always have room for the especially talented newcomer. And that person will usually succeed if he makes an honest stab at applying himself. This book is intended to guide such an effort.

Pittsburgh, Pennsylvania *Victor Kelley*

One
The Initial Step

Professional photography comes in all shapes, sizes, and scopes. It can be architectural, motion picture, underwater, professional, medical illustrative, graphic arts, legal, military, aerial, fashion, food, pet, children, museum, theatrical, governmental, archivistic and so on. Selecting the mode of education for photographic training is very important for the beginner.

The author will begin by advising that the ideal time for such a decision is the last two years of high school. The reason for this is because photography courses combined with a college education will probably form the best background for a successful future in the business. And it is paramount to carefully select a college with an excellent photographic department as well as a good academic reputation. There are very few of them, so choose carefully. College backgrounds have a way of instilling social confidence and maturing the personality qualities that are as important in photography as in most any other successful business.

The university-trained photographer also has the advantage of having been exposed to a curriculum that can include extensive study in art history. By reviewing art, architecture, and philosophies of the artists, the photographer will better understand the basic techniques and ingredients which differentiate the great from the commonplace.

A suggested major or minor in college for the student desiring to enter photography would be English, journalism, or classics. These three are advised because of the increasing amount of writing that is involved in the various areas of photography.

1

Writing, of course, is communicating, and being facile with words, one can express himself more readily with his contemporaries. Photography is nothing more than visual communication. Facility with ideas and the ability to execute them on film is what the trade is all about.

Of particular importance to the college trained photographer is the confidence that he acquires to converse on almost any plateau. He will meet few peers in his business that will be able to intimidate him with their own educational credentials. He also gains an indefinable respect of having *gone through the mill* to achieve this goal.

College offers another advantage to the photographer aspiring to the more sophisticated kind of picture-taking, i.e., advertising, fashion, industrial, etc. Most of the people he will be dealing with will have had college backgrounds. For some mysterious reason, a photographer who is known to be a college graduate enjoys a certain deference from his contemporaries. Perhaps it is because such people believe that anyone who spends four years and thousands of dollars on college, and *then* becomes a photographer, must have something on the ball.

If the expense of college-related photographic training is beyond one's budget, several alternatives exist, some of which offer somewhat better potential in photography than college, especially from a technical standpoint.

One can elect to attend a photographic school where the diet is only photography. These schools usually have programs that take some 12 to 24 months to complete. There are a plenty of charlatans who operate such schools, so one should choose carefully.

A good method of locating a preferred photographic school is to telephone a recommended one and ask

the head of the school for his evaluation of the five best photographic schools in the country. Armed with this information, call every one of the five recommended schools, talk with the Dean of its photographic department, and ask the same question of them. Keep calling the various schools mentioned until a definite name(s) keeps coming to the fore. Then make your choice.

If possible, visit the school first before making a decision. Sometimes a campus visit can reveal a lot of merit (or shortcomings) that would have otherwise been missed.

The same procedure should be used in selecting a college or university that offers photographic training. By appealing to a department head's sense of expertise, the student will come away with valuable information. And such information is necessary to get off on the right foot.

Also, one should examine a school's faculty to determine what their credentials are. Instructors at reputable photographic schools should have at least seven years experience *in the field which they are teaching.* Their photographic showcases should be creatively contemporary, and reflect the current trends. A faculty member whose background is photojournalism is hardly qualified to teach a course in portraiture. In the same vein, it is folly for a photographic instructor who specialized in portraiture to conduct a class in commercial photography.

All too often, an ineffectual professional, who just couldn't cut it in the business world, retires to a photography school to make his living. It shows up in his attitude (averse to changes and disinterest in the students) and initiative (shoots very few photos on his own and hates overtime activities). The more astute photography schools weed out this kind of instructor

3

quickly. But some profit-making schools, interested in high enrollment and primarily the tuition brought in by many students, are slow to excise these mediocre teachers.

It is not the intent of the author to harp excessively on photography school faculty, but to insure that the student and/or his parents carefully check the reputation and administration that the school offers. Schools that stress exercises on just one or two cameras are also to be avoided. The professional world involves large, medium, small and subminiature camera formats. And a good working knowledge of these and associated processing and printing techniques of all film sizes is required background experience to get a good job in photography, as well as attaining a good measure of success in this field. A simple check of just what lab facilities a school has can give the prospective student an idea of just what to anticipate in the way of darkroom procedure and time allotment for photo projects.

Photo labs should have up-to-date equipment and indicate a modicum of neatness and efficiency. There should be sufficient area in the darkroom to accommodate the enrollment and plenty of lab time available to practice darkroom technique. A professional photography school curriculum should include total technique in black and white film processing and printing as well as color film processing and basic color printing. Classes in lighting and composition, with artificial as well as strobe lighting, are an absolute must in training for professional photography.

Instruction in graphic arts-related photography should be included in the programs as well as treating reproduction copying of everything from paintings to transparencies. Classes in *corrective* portraiture,

4

architectural, still life, and publicity photography should be included because the constant practice of these subjects will facilitate the students' ability to light and compose — the two most important ingredients of an outstanding picture.

Beware of any photography school that offers "complete" technical training in less than a year. It is virtually impossible to achieve complete mastery of photography in five years, let alone one year. The sheer time it takes just to practice simple portraiture alone is seldom less than twelve months. Nobody, to the author's knowledge, ever completely mastered *all phases* of photography in his lifetime. The vast number of fields and branches of the trade are too many for any one person to achieve expertise in them in the few short years of a normal lifetime.

Correspondence schools also offer courses in photography. As good as the prospectus literature may seem, photography by mail is probably the least effective method of obtaining a solid background to prepare one for a career as a professional. There just doesn't seem to be any substitute for learning by observation and practice under the guidance of a knowledgeable instructor. As a result, self-teaching is not recommended for the person anxious to prepare himself for professional photography.

Teaching oneself photography from a correspondence course is somewhat similar to tackling a complex recipe from a cook book. There are always absent the hard-to-explain variables that make the difference between success and failure. There is no substitute for observing and then practicing.

Expecting the military to adequately train you for a career in photography is tantamount to anticipating expertise in winemaking from a wino. The military idea of photographic training is using archaic techniques

with ancient cameras to produce unimaginative photos.

Unfortunately, all the monies pumped into the military services annually have yet to find their way to the photographic sections. And one can well imagine what luminaries linger in uniform to teach courses relative to professional photography. One can also ponder just what professional experience the instructors have undergone. Almost any alumnus of military photographic training will admit that its effect was minimal in securing employment in the business.

Military instruction in photography is at best a singular course designed to fit a particular need — the military's. The programs are not oriented to provide a career and they are not meant to. The armed services use photography in very specific circumstances which are spelled out in the myriad training manuals that abound in every service branch. Somehow this specialized type of photography is lost on military recruiters. When they want to tempt the interest of a possible recruit, they have been known to skirt the truth about which they speak. If one does emerge from the armed services with training in photography, it behooves him to take additional instruction to convert what he has learned to civilian applications of the photographic world.

Probably the most effective and quickest method of acquiring a good technical background is the time-honored method of on-the-job training. This consists of working in photographic studios for all the knowledge one can beg, borrow or steal by observing and practicing. Don't expect any recompense for this any more than you would expect a college to *pay you* for attending its classes. Note the word "studios." Since photography has so many phases, and studios usually specialize in one or two of them, it stands to reason

that to get a good, well-rounded education in camerawork, one must be exposed to the various fields of photo work. Each photographer has his own method of shooting, lighting, processing, invoicing, and customer rapport. By observing the methods and routine of different photographers, the trainee can hopefully incorporate in himself all the plus features of his teachers.

The photographic trainee can be disillusioned early in his career to discover that there are a lot of asinine photographers and they are making a lot of money in spite of their shortcomings. Unfortunately, the photographic field has more than its share of these people, but the realist will always consider this all the more reason to enter the field. Granted, it is difficult to accept that in one's chosen career he finds employers or instructors whose blatant ignorance of their profession does not seem to affect their income producing facility.

A fledgling photographer in large cities can quickly absorb technical training by volunteering his free services at various studios in exchange for the knowledge obtained as an assistant to a 'name' photographer. The practice is commonplace and is labeled "paying your dues" to any would-be photographer who is wise enough to attempt it.

As a studio assistant, one can expect to do the most menial of chores from outright janitorial work to hernia-producing totes of heavy equipment such as boom lights, tripods, scaffolding, etc. The thought of entering the photographic world as a coolie to a cameraman can discourage more than a few careers. Some photographers will even refuse to take on "free" assistants until they are just about hounded by them for the 'nth' time for a position or are already semi-proficient in the field. The reason for this is a pro's

desire to see just a little more dedication in the aspirant than the usual run-of-the-mill applicant that he encounters daily.

Nevertheless, the on-the-job training education in photography is still the best avenue to approach in learning the art, technique and business of the profession. Should the condition exist that by some circumstance the photography student cannot avail himself of professional schools, courses, or studio training, he can exercise another tack. It is quite limited in scope because it is dependent on personal ingenuity, ambition and resources available for training.

With a basic book on photographic techniques, a student can absorb much knowledge about film processing methods and camera manipulation. What is important in this instance is for the photographer to constantly attempt to recreate on film any and all pictures, paintings, drawings, etc., to the point that the photos look like copies and closely resemble the model. By doing this, one will always be involved with composition, lighting, angle, dimension and practical technique — those basic tools used by every artist in creating a masterpiece.

Copying the work of others is not a demeaning kind of training procedure. It has been used through the centuries by fledgling artists as a device to develop a technique of some kind, if not any kind. Copying is a time-honored method of challenging one's own ability to produce (easily or otherwise) a similar example of another's effort, be it good, bad or indifferent. By duplicating various subject material until one gains familiarity with method is the whole virtue of this approach to photography. By frank self-criticism of

8

picture quality and enduring the constant routine of duplicating the highly regarded work of others, the student can attain relative degrees of proficiency which is necessary in professional photography.

Where To Look For A Job

A photographer, having completed his schooling and/or training in the field and looking about for a full-time challenging job, usually discovers that finding a job in the trade can be the most frustrating experience in the world. Jobs are invariably hard to come by. And especially in the field that one wants to specialize in.

Seeking out the assistance of an employment agency is not recommended since very few companies with openings on their photographic staff solicit agency help with this matter. The reason for this is the ignorance on the part of the interviewing agency to intelligently evaluate the necessary qualities needed by photographic departments. This does not mean a particular employment agency is bad. It is the peculiar nature of the photographic business that it usually does not occur to the employer to query an agency about potential job applicants. There just seems to be some tacit understanding that employers expect applicants to walk in off the street and, if the interview goes well, the person is hired. And usually on the spot.

There are so many so-called photographers who daily pound the pavement looking for any kind of photographic employment that a prospective employer need only raise the floodgate occasionally to pick and choose his next assistant. It is important to note here that ninety-nine out of one hundred applicants for a photographic position are usually unqualified for the job which they seek. Painfully, they find this out because the potential employer is remiss in rendering a frank critique of the applicant's portfolio and his attire. Occasionally, when the hiring professional has enough

mercy on an applicant, he might bluntly criticize the trembling hopeful and his wares so that the job aspirant may benefit from critique. Such criticism should be accepted without malice. Usually, if a hiring photographer takes the trouble to point out faults (or strengths), he is trying to be helpful by rendering a proper evaluation of the applicant.

The two most important criteria that need be obvious when job hunting is an excellent sample portfolio and sensible dress. A sloppy, disoriented sample case crammed with dog-eared prints and faded, scratched photographs will turn off an employer immediately on seeing the material. Likewise, a sample case stuffed with photos which are not pertinent to the type of job he is applying for will just about guarantee the prospective job seeker a hasty exit. More on this later.

Attire is something else.

The applicant should arrive at the location where he is seeking employment *as if it were* his first day on the job or he was going to be hired on the spot. His garb should also reflect just how much respect he has for the company or studio he is visiting on his mission. When an employer looks at a fledgling cameraman for the first time, the hiring individual assumes that this person is showing him the best he has to offer. If it is otherwise, the insult is obvious. If clothes make the man, they also undo the man. And thousands of photographic job applicants have been undone by their disregard for interview attire.

A commercial photographer specializing in annual reports will usually be underwhelmed by the job applicants showing up in their best pair of faded blue jeans and sneakers. Haphazard hair growth will hardly influence a portrait photographer to hire someone sporting such an undesirable physical feature. On the

other hand, one does not have to dress in a severe conventional manner to be acceptable for possible employment. If the job applicant took the time to research some facts about the company he would like to work for, he would know how to dress for the interview (as well as knowing what kind of portfolio to bring).

A clue to one's total impression when being interviewed by an employer is the length of time of the interview and the acute nature of some of the questions he may ask. Usually, the longer interview is favorable for the applicant, and a tour of the premises is more so. A gift of gab is a desirable asset for anybody, especially a photographer. The ability to put people at ease in his presence is a rare quality and is necessary for any photographer who works with models or groups of people.

For the interviewee, a knowledge of current affairs and trends in the photographic profession is desirable. Avid interest in the art world and related subjects can only be social money-in-the-bank for the applicant. Confidence in speaking can oftentimes be that little something that may tip the balance of judgment in one's favor. Besides, it can only improve one's social and psychological development.

Be specific when approaching a company for a job. If you do not know whom to seek out at a given company, telephone in advance and ask the receptionist who would be the pertinent person to talk to for a photographic position. Once you get the information, call for an appointment of the feasibility of having your photographic samplings evaluated by that person. It's deadly to come right out and ask, "Are there any jobs available at your place?" People who hire others want to see who they're hiring. If you can't secure an interview the first time you try because the

12

employer is "busy," ask permission to call on him at a more convenient time. The answer will invariably be "yes."

Sometimes the applicant can walk into a place cold and hope to see somebody without an appointment. Oftentimes it works. More often, it doesn't. Occasionally one hears of job openings through camera store salesmen, other photographers or through professional photographic trade associations. Some professional photographic groups incorporate job-clearing departments that spell out what positions are available, what they pay and whom to contact for the job.

At times, some job openings are listed in photographic trade magazines. Invariably they are in low density population areas that don't appeal to the budding professional because the big city status is missing. But for somebody looking for a start in business, such jobs could be the vehicle to get one's career rolling.

College and high school vocational counselors can be possible sources for work in the field, but generally, their knowledge of what it takes to succeed in photography is minimal.

Looking for a job should not be the intimidating experience that many people find it to be. How else does one get a job unless he goes right out and asks for it? As unpleasant as the experience may seem to be, it is simply a time honored process that others have been doing for eons. What is very important is how one goes about asking for a job. This is when one's abilities to project his or her personality and magnetism come into play. This is when an applicant has a golden opportunity to demonstrate other personal assets that can only be appreciated by face-to-face contact. It is usually this personal confrontation

that people dread because they have no faith in their ability to project themselves well. This condition can be magnified to the point that it affects one like voluntary visits to the dentist.

Remember, how else can an employer hire you unless you inform him that you're looking for a job?

Three
Book

Next to a strong affable personality, the most important salable feature a photographer can manifest to a potential employer (or customer) to enhance his image and impact is his portfolio, or *book*. The book is an elite sampling of the photographer's work. Indeed, it is a complete revelation as to the photographer's sensitivity, artistic merit, technical ingenuity, fastidious nature and total imagination. It is the current embodiment of the photographer's day-to-day potential with a hint of what his future status could be.

Unfortunately, among too many photographers it is nothing more than a haphazard collection of whatever is lying around that has been seized and tossed into an attache case or battered envelope. Perhaps this is nature's way of forewarning prospective employers (and new accounts) to avoid this kind of photographer and his sales pitch. A photographer's book should be so strong that he could be hired sight unseen by anyone representing him (which, by the way, is a rather lucrative trade to quite a few photographer's reps). It should contain enough samples to convey flexibility, professional largesse, favorite assignment forte, and hopefully a singular style or feeling that can be readily perceived.

It is not unusual to achieve this attitude within a dozen or so photographs. It becomes more difficult to determine if there are too many prints or trans-parencies for the viewer to behold. A similar situation would be a wine taster confronted with fifty wine-filled glasses rather than five. The judgment on the five excellent wines will be more memorable than

the assortment of fifty. The photographer's book should also be changeable depending on who is going to view it. It should contain those samples that will most likely excite the interest of the viewer. Obviously, if a photographer is job interviewing with a prospective employer whose work is illustrative, it would be inadvisable to bring along samples not pertinent to his business, i.e., weddings and portrait samples. Of course, if one's book is limited and he has outstanding samples in a different type of photography, it is advisable to include them in the portfolio.

Before showing a portfolio to anyone, the photographer should scan every picture painstakingly and keep it in the book only if he is definitely convinced that it is his best work. If it is borderline, it should not be included. Material that has been judged poor by a series of employers should be removed from the portfolio lest it affect future judgments of one's best work.

The portfolio photograph should be large enough to be conveniently viewed without squinting; the larger the print, the better. Also, the larger the transparency, the better. Photographs should be mounted in some attractive manner on a rigid piece of material (cardboard, masonite, or whatever whets the fancy). They should look fresh and snappy and should be free of bent corners. They can be borderless, with or without mats, but they should be singularly impressive.

If slides are going to be shown, the photographer should bring the projector and necessary equipment to effect a quick, clean presentation. He should be prepared to render a short, concise commentary on any of the photographs that he believes warrant extra attention, such as complexity of assignment or restrictions involved with making the exposures. Showing slides ganged in a plastic viewing sleeve is

usually a disaster since the naked eye squinting to see the image usually fails to be overwhelmed by such a small picture area, let alone a conglomeration of them all on the same page.

Too often the proximity of a group of excellent transparencies tends to diminsh their individual qualities. When the eye has to do battle with a range of interests, it can very easily lose the impact of a solitary subject. If slides are included in the book, they should be mounted in a black holder/viewer *no less than 8 x 10 inches,* so that it can easily be held by the observer . . . and, to minimize the possibility of fingerprinting. The transparency should be centered in the black mat board and have a protective transparent sleeve around it. Having a lightly translucent backing on the slide will aid in the viewing of the picture if held up to room light.

Given a choice of showing a number of small slides along with some prints, it is better to show nothing but slides. If need be, make slides from your best black & white prints, and the same from color prints, if that is the only way in which it can be done.

As mentioned before, beware of showing too much material to the viewer. When projecting transparencies for the observer, be prepared to keep a running commentary on why you justify this or that photo in your book. An employer or customer is always interested in why the photographer shoots a certain subject in a particular manner and the machinations involved in achieving the desired result. It is through such revelations that one can intelligently evaluate the ingenuity and skill of the photographer in producing a superior picture. A distinct benefit in using the slide projector to display one's portfolio (if the conditions are convenient to the viewer) is the impact that the size of the image has on the observer. Most pictures

seem to receive favorable criticism when made outsize, so this method of displaying *samples* shouldn't be lost on the cameraman. Besides, most people like to view large photos, and when excellent photography is displayed in heroic size, more favorable judgment is likely to result.

Never include any photograph in the book that has to be excused for a rip, dust specks, stains or any other undesirable feature. Keep in mind that the photographer's ability will be judged by the *worst* sample in his portfolio. Anything less than a first quality sample has no place in the cameraman's book. It is an insult to the person viewing a photographer's portfolio to critique pictures that show evidence of being physically worn and torn as if they were recent refugees of the trash can.

On certain occasions it is wise to include a series of picture story proof sheets that one has photographed on assignment or shot on his own. Many prospective employers, editors and advertising art directors are keenly interested in how the photographer develops the pictorial aspect of an assignment frame by frame. A good series of proof sheets attractively presented may oftentimes be the major selling feature of a portfolio. It is a capsulized illustration of how a photographer thinks while working. Also readily transparent at a glance is the cameraman's knowledge of lighting, composition, exposure consistency, and confidence. Inconsistent exposures are a dead giveaway at revealing a photographer's technical incompetence.

Just about every photographer and/or salesman is nervously reluctant to make that first call on a client or prospective employer. It is tantamount to stage fright when the actor is unsure of his lines and his audience. But the plunge must be made, and that is how

business and jobs are gotten. It is paramount that the photographer pursuing new business constantly attempts to surmount the distaste of initial contact with a possible new customer. It is probably this attitude that makes it advisable to meet new accounts over cocktails and/or lunch (the photographer picking up the tab, of course). The casual atmosphere of a bar or restaurant filled with people has the therapeutic effect of alleviating the photographer from the "on stage" syndrome that an office can affect. When using a luncheon approach to new business, the client can review the photographer's portfolio after the meal when the two parties have had ample opportunity to feel out each other's interests and attitudes.

The ever-changing portfolio also offers a bonafide excuse to meet with prospective employer or a client regularly if only to reveal what the photographer has been shooting of current interest. Advertising people in particular are always searching around for new visual approaches and exciting imaginative photos that they can possibly incorporate in their designs and ideas. A photographer's book in this instance is a valuable tool in follow-up business and keeping his name before the client.

Having a first class portfolio and not getting an opportunity to display it to the people of one's choice can on occasion be very frustrating. This is particularly the case in large metropolitan cities. One can well imagine the battle of the New York or Chicago photographer to get an appointment with a popular advertising manager or art director. Because competition is so keen, the photographer has to constantly try to get his big toe into doors by having sample material that will instantly stir the imagination and stimulate ideas in the mind of the viewer. A point to remember here is that oftentimes an outstanding

portfolio can bring a client's associates running to view one's book. After this happens a few times, the assignments begin to drift in.

Too many photographers have a tendency to stop in cold to see a potential employer or client. This method is not to be advised because the odds of success are against the visitor. The inference that the person to be contacted couldn't be so busy as to deny the photographer an audience at that time is hardly flattering to the interviewer. Many a chance for business has been machine-gunned by this inept approach. As often as photographers' clients themselves are inundated by appointment requests, the majority of them in the trade will make an honest effort, whenever possible, to see a new face and a fresh portfolio. Most progressive persons realize that avoiding exposure to contemporary talent invites mediocrity and all the stale fixations that accompany it. A paramount point to remember is that many a photographer's creative ideas stimulate his clients to incorporate these graphics in upcoming advertising campaigns.

People in advertising and associated trades always keep their eyes focused on new and fresh trends. This is an integral part of their business. Any supplier (photographer) who can consistently make his customer look good before and after an assignment has a bountiful future ahead of him.

Keeping an updated portfolio is an automatic reminder to maintain selling practices with periodic regularity. Besides furnishing the photographer with fresh, lively material, it makes him judge his progress as a professional photographer. Secondarily, the portfolio offers the cameraman a ready made, current one-man show of his efforts. It doesn't take much of an effort to display and receive publicity for such shows,

especially in smaller cities. Banks, hotels, libraries and local department stores are usually amenable to displaying well-presented photography since superb pictures, in addition to reflecting cultural taste, also bring in the public. And among that public lurks a potential employer or a new customer.

Four
News Photography

The life of a news photographer can appear exciting and important, and in some cases, it is. An important point to remember is that each major newspaper, magazine or journal has a particular style and that, to a degree, the news or editorial photographer is expected to observe that style and incorporate it into his photographs – a limited freedom, so to speak. Because of this very restriction on style, the exceptionally talented news photographers change jobs frequently. They constantly search for a publication that permits more variety of choice and one free from the petty prejudices of a jaundiced editor or publisher.

The style and flavor of a magazine or newspaper is dictated by upper management. Anybody working for such publications becomes painfully aware of the do's and don'ts of the hierarchy immediately upon accepting employment. The list of taboos ranging from certain words to subject matter is revealed to the newcomer in short order.

Photography is treated in much the same manner. Long-time editors are rarely dynamic people nor exceptionally imaginative. By following the accepted traditions of the publication throughout the years, an editor's job is almost certain to materialize for the faithful employee. A cameraman, new on the job, becomes painfully aware of this conservatism fairly soon and finds himself waging a constant battle in an effort to upgrade the pictorial side of the news. The struggle can be very discouraging to young photographers whose image of a news cameraman is idyllic in concept. All too often, the news photographer

finds himself confined and trapped ideologically, but making too much money and fringe benefits to leave the publication. Some truly remarkable photographers have chosen the security of the news field rather than chance exploiting their talent and enhancing their reputations in a more challenging branch of the profession.

Of course, there are news outlets that are exceptions to this general trend. Some of the newer newspapers permit almost excessive freedom and license to their cameramen in an effort to stimulate circulation and interest. In addition to using their own photographers, quite a few of these publications regularly buy pictures from outside news sources. Weekly newspapers and small town daily publications usually accept and print just about any kind of photograph. It offers a photographer maximum flexibility to try different approaches from the usual tiresome hackneyed shots such as groups, award presentations, et al. However, in exchange for all this freedom, the pay is all too often poor.

The smaller daily and weekly newspapers usually lack the vast amount of advertising space that the larger newspapers boast. In fact, the thicker the publication, the more salable it becomes, and advertising is the best method to fatten a publication. When there is a lot of advertising in a paper, there is always extra room for "filler" items, such as photos (large photos) or wire service stories that are produced for just such a purpose.

Small newspapers that appear weekly or monthly are always on the lookout for interesting photos that can be used to make the issues more interesting to their buyers. It is usually not very difficult to place an appealing photo with such a publication. Oftentimes such a paper will regularly run a "picture page" to

stimulate graphic interest in the newspaper as well as future subscriptions.

The usual manner of entering the news field is to begin by submitting photos to daily or weekly newspapers and magazines on a piecemeal or speculative basis. Some publications can't afford full-time photographers (unless they can also write - and here is where college comes in), so they retain them part-time. More than a few copy boys became photographers when an editor threw a camera at them and changed their titles. Reporters who would often have to share a photographer would find themselves taking their own photos, developing them, and then experimenting, taking more shots until their careers overnight became that of photojournalists.

When an opening does exist for a photographer on a publication, the part-time man accepts the position and upgrades himself. Always alert for potential jobs available elsewhere, the news or editorial photographer keeps advancing up the ladder until he arrives at the one newspaper or journal which satisfies him financially and offers a constantly challenging job. Beginning salaries are invariably low and may remain low for several years. In the newspaper business, a five-year internship is not uncommon.

True to form, most news photographers always seem to be disgruntled about some facet of their employment, but this seems to be the news syndrome that affects many people in the trade. News cameramen appreciate the certain air of envy they provoke among their friends and neighbors because of the aura and excitement generated by the job. There is a certain esteem that is rendered the news media because of its proximity to influencing the general public, and this fact is not lost on employees of news outlets. Being a news photographer can fulfill certain

ego requirements that have been sought after for years by the cameraman.

Because deadlines oftentimes affect the quality and impact of a photograph, news photographers have a tendency to become staid in their approaches to routine assignments. They cut corners in lighting a picture properly, or use the wrong camera to shoot an assignment just for the sake of convenience. The pressure of a deadline can be just enough to influence the photographer to come away with a mediocre picture rather than capture a great one.

The majority of news photographers like to travel light and will forsake a heavy long lens or a bulky wide angle lens (which may render a more sensational photo) for the lighter, easier-to-use lens. This is truly unfortunate because so many of the run-of-the-mill pictures taken daily by news cameramen could be so much more compelling if the extraordinary camera and lens treatment were utilized.

These pitfalls are mentioned here to advise the news photographer aspirant to steer clear of the traps of mediocrity that such a profession *conveniently* induces.

Editors also have a way of influencing the work of a news cameraman. A dynamic editor or publisher can be the catalyst in producing imaginative photographic assignments from his staff. Because of these editorial challenges, many a cameraman has remained with a publication at less pay than he could get elsewhere. Job satisfaction ranks high in the priorities of a news photographer as well as the sense of fulfillment that the cameraman experiences of being part and parcel of daily news events.

Five

Corporate Photography

Getting a position as a corporate photographer oftentimes depends on being in the right place at the right time or knowing somebody who works for that company and is aware of a vacancy in the photography department. Rarely are these positions advertised. The few that are usually are with companies in remote areas, or the jobs are so poor paying or working conditions so undesirable that there is a large turnover of personnel.

The corporate photographer usually is paid well and receives many fringe benefits that small studios and independent photographic employers could never match. Advancement within the corporation can be slow because photographic staffs are not very large, with little turnover of employees. This can become a source of frustration for the exceptionally talented photographer because of his instinct to demonstrate his capabilities and to receive adequate recognition for it. A similar analogy would be an inventor who works for a company that ignores his potential.

Quite often, the positions in corporate photography are filled by cameramen from other branches of the field. Occasionally, when a news photographer tires of his routine, or perchance a commercial man decides to go for the security offered by the large company, he will apply for such a photographic vacancy.

The corporate photographer oftentimes enjoys many of the more glamorous attractions of the life of a professional photographer. Sometimes a lot of travel is involved, especially in a company that has offices in different cities. And the assignments can be varied and

challenging enough to be personally fulfilling. Of course, the photographer with seniority gets his choice of the juicy jobs, and rank has its privileges, etc.

What the corporate photographer gains in security, salary and fringes, he loses in his personal status within the company. There are inherent limitations as to his position with the organization. The title of 'chief photographer' for a corporation is impressive to friends, neighbors and associates, and possibly to the cameraman himself, but his niche within the managerial staff of company hierarchy is on a very low level. Because of this condition and the nature of the position, one rarely finds an ambitious photographer in the corporate field.

A common sad fact in being a corporate photographer can be the condescending attitude of higher management toward the photographic department and its crew. Too often, the company cameraman is treated with the same deference as a government janitor. Non-person is probably the better label. Since corporate photo staffs are generally small, any and all kinds of requests (some important, but many frivolous) are dumped in their laps, the result being a daily routine of overwork. Naturally, the sensitive photographer takes umbrage at this treatment, but many swallow their pride and resign themselves to this attitude realizing that the corporate fringe benefits can be compensatory enough to offset this undesirable side effect.

Not all corporation photographic departments enjoy the benefit of having the most up-to-date camera and processing equipment. Situations differ dramatically among those companies who deem it necessary to have in-house photo labs. There are some very small corporations who have large and elaborate photographic departments, and there are those very large companies with shamefully primitive labs and equipment. A quick tour of any studio and darkroom facility will reveal

27

exactly how a given company regards its photography department.

Corporation photographic salaries are generally higher than those found in private businesses, especially where labor unions have a foothold. Cost of living increases come regularly and employees usually enjoy generous paid vacations and numerous holidays.

The smart corporate photographer will constantly try to keep his name prominent among his local and national pictorial brethren. Obviously, any company worth its salt likes to think that its photographic staff is always winning awards and receives regular recognition from professional organizations for its accomplishments. Favorable notoriety never hurt anybody's reputation and provides ample ammunition for the photographer looking for pay raises as well as promotions. By regularly displaying his photographs locally (or nationally, for that fact), the corporation cameraman can develop a reputation that could possibly assure him a job when personnel cuts periodically decimate employees during slack business times.

Employee cutbacks during economic recessions have a tendency to affect corporate photographic positions early. It is almost ironic how a typical overworked photographic staff can find itself considered 'fat' or extraneous and unessential when management decides to reduce staff. This awareness of corporate employee policy during poor economic times should have a bearing on anyone weighing corporate employment. Any company having a history of early or prematurely scuttling of its employees at the first dip of the Dow Jones average should be carefully scrutinized by anyone looking for a position in its photographic department.

All too often a job with a corporation can mean many years in the darkroom and processing labs before positions become available as a shooting photographer.

This is not to say that processing work is dull and drearisome. On the contrary, it can be extremely challenging and fulfilling depending on the requirements of a particular job and the effort needed to bring off an assignment. The darkroom technician requires just about as many skills as the photographer to produce the original concept graphically. Perhaps even more. The technician is charged with the responsibility of successfully producing on film or paper what the photographer originally intended. More often than not, a cameraman's mistakes can be corrected by an able darkroom assistant, a known fact that many photographers are averse to acknowledge. A photographer is only as good as his film, prints and transparencies. Many a cameraman has gained (or lost) a reputation or a client contingent on the ability of his darkroom technician.

It is notable to mention here that taking a job as a photographer or a photographic trainee is not necessarily a good stepping stone in one's career because of the inherent limitations characteristic of corporate photography. A particular company usually uses its photographic staff in a rather static manner, that is, the concentration of pictorial efforts are centralized on certain products, services or that particular thing around which a company makes its income. The photographers of a glass company are probably expert at shooting buildings or items made of their product, but may be woefully inadequate at other subject matter because of the product or service concentration required by their jobs.

Photographic equipment salesmen and supply house clerks usually have inside knowledge as to what jobs are available and valuable information about who is doing the hiring. Oftentimes these salesmen are requested to search for applicants who can fulfill the job requirements

of a particular company.

The corporate photographer is less likely to enter the ranks of the self-employed for several reasons. As mentioned before, it is difficult to give up excellent fringe benefits for an unsure future. Also, the necessary customers to provide bread and butter income need not be solicited, a feature that some cameramen find too distasteful to confront. The photographer who works for a studio that sells its services commercially can make the step much easier. Familiarity with the market and the customer is the difference.

Corporate hierarchy are usually amenable to underwrite the costs of periodic professional refresher courses for its photographers. This affords the corporate cameraman a chance to bone up on the latest equipment and photo trends that descend on the professional community daily. It does furnish the photographer with a mini vacation and affords him an opportunity to meet with his peers and exchange ideas and air his technical problems. A periodic exchange of ideas and methods among photographers is always a healthy thing to sharpen one's abilities and experience, and the frequent professional seminars offered by teaching professional photographers are an invaluable aid in augmenting one's day-to-day proficiency.

Cinematography

Preparing for a career as a moviemaker is usually accomplished by on-the-job training or going to a university that specializes in this visual art form. Most of the colleges that offer top rate courses in cinematography are in southern California, near the movie colonies. It stands to reason that these schools get their reputations because of the proximity to an abundance of elite professional talent that they can draw from for faculty.

Anybody who is seriously planning a career in film making is well advised to seek enrollment in such a university since such educational credentials are almost mandatory to advance quickly in this business. The school curriculum is such that all phases of movie production are touched on with a degree of expertness that enables its graduates to expand their talents much more quickly than if they tried learning on thier own.

Being a graduate of a "name" school in cinematography has another asset in that the alumnus enjoys a familiarity with the Who's Who of filmdom. The very strength of the curriculum in these universities allows for a greater saturation of learning and techniques. The majority of the big names in cinematography invariably have come from a college background. If one is impatient to get into the trade and advance quickly, he should take the higher educational route.

Pertinent to mention at this time is to note that professional cinematographers are strongly unionized, especially those connected with large motion picture production houses. The membership is also notoriously

difficult to break into. Therefore, it is essential to to have first rate educational credentials as well as some "friends on the inside" to achieve such acceptance by this union.

Smaller independent motion picture studios are not unionized, so this particular problem is not encountered.

On-the-job training or any other method can be a long drawn out type of frustrating education for the cameraman wanting to specialize in serious motion picture making. Granted, there are thousands of photographers who make a good living shooting films that do not require special talent. Take, for example, the local television cameraman who is rarely called upon to shoot anything more complicated than a straight news story, sometimes with sound. Or a corporate movieman who is filming an experiment in a laboratory. Or even a nature photographer who may be recording the hibernation activities of a grizzly bear.

Companies that specialize in industrial films, government training films and advertising commercials can be excellent sources of training for the fledgling moviemaker. Generally these companies offer a basic course in just about every aspect of cinematography that the universities do, except that it takes longer to glean the knowledge and means working at little or no pay to receive the benefits of on-the-job training.

A typical neophyte who tries landing a job with a film company usually starts as a "grip." Qualifications for being a grip include a good basic knowledge of electricity, an understanding of the various kinds of lighting equipment used, and the intelligence to recognize a modicum of composition as dictated by the camera operator supervising the scene. Having a strong back and plenty of muscles also helps, because of the endless shuffling of heavy equipment that the job entails.

The position of grip is an ideal way to observe how the whole movie-making process comes together. It is an

ideal training job (if not simply a good full time position) to determine just what phase of cinematography one would choose or on which to concentrate.

As humble as this method of absorption is, it has come to represent the time-honored method of learning the trade.

Because the grip is such a key person to the successful production of a movie, the position of "Key Grip" has attained such a level of importance that many motion pictures mention his name in the credits. The grip is an integral part of lighting a set, determining electrical requirements and repairs, camera angles, setting up sound equipment, preparing film magazines and cameras for the job as well as a myriad of other chores, each of which will prepare him for whatever part of movie making he wants to pursue. Developing this technical expertise is essential to realizing any degree of success in the field.

Having a working knowledge of still photography can have its benefits also to one interested in films. Since the still photographer is primarily concerned with a single frame of film properly lighted and composed, this training will make him better at recognizing and arranging more dynamic angles that are pleasing to the eye. Quite a few still photographers of some fame have easily made the transition to motion pictures. The reverse is a rare occurrence indeed.

The amount of patience required to be a successful film maker is almost as great as the sheer bulk of equipment usually required to shoot a film. The miles of electrical cables, barn doors, light stands, clamps, tape, booms and miscellaneous paraphernalia required to set up the most basic scene is so staggering that one wonders how any progress is maintained throughout a shooting schedule.

Over the past years, some high speed movie films have

been developed that can allow the photographer to bypass the need for extensive technical setups, hence less manpower involved. This situation has brought more and more new people into the trade and has changed the conventional methods of film making for the better. In the past, because the cost of producing a film was so high and the results so unpredictable, few people gambled enough to make a film on their own. With the current change in living, taste, mores and fashion, less expensive films can be made with a lot less financial risk.

Because numerous careers are launched by amateur hobbies taking more time and interest, the movie enthusiast can find a ready market for his more energetic efforts. Since television stations in metropolitan areas can only afford a limited staff of cameramen who can cover just so many assignments within a certain territory, it stands to reason that the stations are interested in those cinematographers who can provide them with interesting footage that is newsworthy from time to time. These satellite photographers, or 'stringers' as they are called in the trade, are an important source of news coverage for most TV stations. What's more, the broadcasting companies don't have to maintain those stringers on a full time salary. They only have to pay for that which they wish to use.

The ambitious young motion picture photographer with some degree of competence can very easily work his way up the ladder from a stringer submitting unsolicited footage to a staff job on a metropolitan television station, if he consistently turns out unusual films. Once he is on the staff of a recognized news source, he will have ample opportunity to upgrade his career even more quickly.

At the zenith of prestige in moviemaking is the theatrical photographer. First rate credentials and

background are demanded with almost all the trained talent being plucked from those schools who specialize in motion picture production. Not only is a good scholastic background a major requirement, but also a long list of contacts that can open the right doors for recognition. With the most stringent of qualifications required to succeed, it is understandable why few cameramen make it to this select society of filmmakers. Stamina and a certain stick-to-it-iveness are paramount in those people who want to become theatrical cameramen. Because the demands of theatre photography encompass top reputation as a craftsman as well as mechanical expertise, few cinematographers are able to reach this exalted plateau.

Cameramen learning their trade by on-the-job training rarely make it in the theatrical business simply because there is not sufficient time to or occasion to absorb all the complexities of film producing, and then finding a foothold to launch one's career. As glamorous as this field appears from afar, it is nothing short of hard work and long hours. However, if one is able to reach the top, the public adulation, prestige and financial remuneration seem to warrant all the struggle and effort to get there.

Spinoff careers from cinematography can be very rewarding. Because there are so many facets in movie making, each demanding special talent, more than a few avocations have been occasioned by people choosing to specialize in what they found they could do best. Film editing, screen direction, sound dubbing, special effects, etc., are several of the many professions which are directly tied to the movie industry and which require a working knowledge of the cinematic business. As mentioned previously, there are even less taxing positions related to the profession that can sustain daily interest and pay a living wage, such as a grip, a gaffer, prop man, stage manager, etc.

35

Self employment in the movie business is quite different from still photography. Since so many people are needed to produce a film, the self-employed cameraman usually has to hire his help piecemeal for specific contracts. He might need to rent or buy additional equipment, have the manpower to move it around, and even need a particular cameraman for certain sequences, i.e., an underwater scene. Accumulating a list of part-time employees that are reliable is a never ending job. Because the nature of the business is sporadic and unpredictable, temporary help is not always available when needed, adding to the woes of the entrepreneur.

The initial investment for moviemaking is also greater than in still photography. The amount of lighting equipment, recording instruments and mountainous items of miscellany, let alone cameras, is many times that of a still photographer. A studio or ready availability of a studio, is an absolute must for the moviemaker. Transporting equipment (and a lot of it) for long distances is commonplace to the trade and becomes somewhat of a nightmare when air travel is involved. Film processing machines are a costly item to maintain but necessary for the smooth operation of any studio. The sheer bulk of equipment and space to store it can be discouraging to the newcomer in business as well as the huge expenditure necessary to maintain an adequate inventory.

Partnerships are more ideal in the movie business if only for the fact that the more people to share the work load, the better the chance for success. Usually a cameraman will team up with someone who has multiple abilities in the movie industry. Partners who can provide the needed expertise between (or among) themselves stand a fairly good chance of survival in the business as long as their respective personalities blend with their

progress. The more multi-faceted a film company is, the better position it is in to bid a contract and produce a superior motion picture.

The cinematography business is generally a career of extensive travel and little home life. It is rarely boring, though oftentimes tiresome from a physical standpoint. Successful moviemakers enjoy a charmed life attendant with all the glamor that traditionally accompanies it.

Wedding and Portrait Field

The most common variety of photographer making his living in professional photography is the wedding and portrait cameraman. The word *common* here refers to numbers only. The reason for this is that there is more of a market for wedding and portrait photos than any other kind of pictures. It is also the easiest type of photography in which to make a good living because routine hours can be scheduled and the pace is less hectic than in other phases of the business such as photojournalism, press photography, advertising, etc.

Albeit the wedding/portrait man does have seasonal business (summer Saturday weddings and fall school portraits) which keeps him busy, his customers realize that good pictures of this kind take time to produce. And if they think otherwise, it is up to the photographer to rationalize the long wait for proofs, etc.

Most portrait and wedding photographers have a standard setup with standard lighting that they habitually use if only for the sake of expedience. Occasionally they will experiment with various lighting or groupings, but more than often, they have a tendency to stay with the tried and true. This is invariably the case when business is brisk.

At the one end of this spectrum is the passport photographer who usually has no pretensions of being an *artiste*. At the other end is the *artiste*. His esthetic photographs are magnificently conceived and executed. And so are his prices.

What is so tempting for photographers to choose this branch of photography is the knowledge that "I can do better than that guy who's making money hand over fist."

From such feelings are new studios spawned.

Just about every photographer who works for a wedding or portrait studio believes he has the ability to operate one by himself. It is usually the accumulation of capital that keeps him from doing so. After all, if one is going to buy an existing studio or start one from scratch, a considerable sum of money is involved.

A studio is a "must" for this type of photography. This is especially true in large metropolitan cities. In smaller towns, a photographer's house can be converted into such use and be immensely successful. Ultimately, it is the nature of one's community that dictates what kind of studio one should have.

Shopping mall studios deserve more than cursory consideration these days, especially where there is a proliferation of people milling around. Granted that long leases are hard to swallow, and not for the pessimist, but the traffic can be such as to insure initial success to a "new" studio.

Considerable thought given to decorating a mall studio with large mural-sized color prints, enlargements of pets and unique still-life color photos can bring in customers if only to "ooh and ahh."

The wedding and portrait studio has a distinct advantage that other phases of photography don't have. It has a conglomeration of processing houses just begging for their color printing business replete with monthly price slashing. These processing labs range from poor to excellent and their prices are usually the bellwether of their expertise. Because of this glut of labs fighting for the wedding/portrait business, the photographer doesn't have to spend the money to install his own color lab and hire the manpower to run it. And since there is usually a decent time frame from which to work, the photographer doesn't have to be too concerned about delivery dates. The icing on the cake is

that he doesn't have to prepay the labs for the pictures either, hence a better cash flow for the studio.

Self-employment in the wedding and portrait field of photography can be done in several ways. It is understood, of course, that the photographer desiring to make this type of camera work his career has a working knowledge of how such an operation is managed. Ideally, the photographer will have had some experience working in a *successful* portrait studio and will have become somewhat familiar with the business attitudes of such a shop. It does not necessarily follow that a good photographer with a charming personality and sales ability will be an astute financial manager. The number of portrait photographers that have failed for such business shortsightedness are many. More about that in a later chapter.

Buying a studio outright is a commonplace transaction for the photographer who has financial reserves to tap or is commercially bold. Usually the cost of a studio is computed on the basis of one year's gross receipts plus the fair value of whatever equipment goes with it. Hopefully, the photographer buying a studio has some familiarity with the city and surrounding area, and carefully researches the reasons that the studio is for sale. Again, the studios that are up for sale can be found in local newspapers and national trade magazines.

If a photographer buys a studio in an unfamiliar city, certain conditions should be attached to the sale. The primary one should require the presence of the previous owner on the premises for no less than three months. Six months to a year is better. The reason for this is to make the transition as smooth as possible. The buyer should insist on being introduced around town to influential people and groups that have been instrumental in securing past business. Since it takes many months to capture the flavor of a new city, the buying photographer

will need all the help he can get to orient himself with the town's business attitudes.

Before purchasing any studio, the interested photographer is advised to make local inquiries as to the reputation and financial success of the property. Prior managers are usually good sources of information on this topic as well as the accountant who serviced the studio's books. The popular excuse for selling a studio because of "poor health" has been overdone. Too often it means that the selling photographer's reputation was so bad that his poor health came from not eating regularly.

A credit check of the studio for sale is another item not to be overlooked. A simple thing like a bad credit rating can put a new owner in a bind with his suppliers. Because photographic supplies are expensive, this condition could cripple the new owner in his bid to get off on the right foot.

A photographer desiring to buy a studio should beware of the old pressure game where the seller indicates that one or more parties "are close to buying the studio." Such gambits are invariably used by almost anybody selling anything. An ounce of precaution in keeping oneself from being flurried into a questionable sale is well advised.

It is important to stress that buying a wedding and portrait studio is quite different from buying, for instance, a commercial studio. Usually, a portrait studio has readily available customers from longtime association with schools and community citizens as well as a permanent location that is an advertising plus in attracting passersby. Commercial studios are altogether different. Business is usually dependent on a personal relationship between a particular photographer and certain company representatives, and once this liaison is broken, the financial picture is considerably lessened.

Opening a portrait studio from scratch is probably the

most difficult photographic venture that one can imagine. Financial reserves for at least six months of operation should be squirreled away beforehand (See FISCAL RESPONSIBILITIES chapter). And speaking of squirrels, the newly baptized portrait man will have to clamber around like one to create enough initial business to keep the studio on its feet for the first few years of operation. Newspaper and personal advertising are a must. It is difficult to commit money to advertising when one doesn't have it to spend, but it is a *must* gamble to achieve in any arena of success.

Joining community and church groups such as the Rotary, Lions, Kiwanis clubs, etc., is definitely helpful in having one's name and reputation circulated advantageously. An occasional free job doesn't hurt either. A massive public relations campaign must be launched to keep one's name in the public eye and to garner new business from such a program.

One major reason for the demise of a new studio can be the photographer's approach to his customers. He has to be diplomatically charming, exude confidence in his abilities, strikingly imaginative to attempt the unusual, and genuinely like to communicate with people. Of course, everybody believes himself to be an amalgam of these features, so a lot of frank evaluation of oneself is in order. If in doubt as to how you stand, begin by thinking of yourself as the world's biggest bore. A periodic course in self-improvement is always advisable just in case one becomes self-satisfied with his approach to customers and business. These programs seem to creep into one's daily mail once started in business (any kind of business for that matter). A Dale Carnegie course never harmed anyone and has helped thousands of egos that have gone awry throughout the years.

Rates charged for photographic services rendered

vary from city to city, and for that fact, from region to region. It behooves the photographer to charge no more or no less than the traffic will allow. Naturally, a photographer who invests in expensive trappings for his studio will charge more because of his overhead. And the customer, once exposed to the frills of the studio, understands this. Conversely, it is difficult to obtain a high price when a photographer's studio has the general appearance of a warehouse.

Refresher courses for the small photographic businessmen are definitely recommended if only to keep abreast of what's new in the business world and renew one's stimulus in his trade. New and contemporary photographic approaches to the portrait field arrive almost regularly in the daily mail. It behooves the photographer to incorporate these popular changes in his repertoire to attract new business and keep himself fashionable to the times. Many diverse courses in fresh ingenious avenues for the portrait man are offered throughout the country via seminars that may last from several days to several weeks. Usually this information can be gotten by inquiring from the management of local photo supply houses or making a query of the larger photographic manufacturers.

Portrait photographers who do not keep abreast of radical changes in the trade are going to lose potential business to establishments that are more money oriented. The portrait man has to be capable of rendering work that has separate appeal to three generations. Being able to please a wide spectrum of customers is not easy. It demands a photographer's constant attention to ferret out the kind of work that will sell.

Commercial Photography

Just to clear up an oft misunderstood term, commercial photography engenders just about any and all phases of the field. What the commercial photographer is saying is "I am very good at many kinds of photography." Regardless of just how true this is, thousands of cameramen label themselves "commercial" because of the general variety of assignments they seek and shoot.

Of late, the commercial photographer has come to disdain weddings and baby pictures (sometimes called "kidnapping"). He also sticks only with still photography rather than pass himself off as a movieman too. Passport photos are also beneath him as well as high school portraits and yearbook-type pictures.

The commercial photographer does not necessarily have to have a shooting studio as such. He can survive very well doing nothing but location assignments. However, he should have darkroom facilities for processing and printing his shots. The reason for this is because of the frequent customer demand for rush service and special requirements in rendering the final product. It would be an impossible task to try to satisfy commercial customers by farming out one's lab work. Any photographer who is rash enough to attempt such a "studio" without lab facilities to back him up is taking a bad gamble on a successful future.

Most commercial photographers do have studios because they find their assignments frequently call for controlled lighting in a controlled atmosphere. And a studio is the obvious place to accomplish such photos. The large amount of special lighting gear and

background devices dictate that an ordinary household with low ceilings and all is *insufficient* to accomplish the majority of such commercial assignments.

In a constant battle to keep the studio equipment from crowding him out of his own studio, the commercial photographer invariably lusts after more and more room to work in. Of course, another problem creeps into the commercial man's life once he has a studio and that is the need for an assistant. After all, no one can expect to move all this equipment around by himself let alone work the camera. This is why commercial studios are invariably operations with two or more people involved with day to day assignments.

The commercial photographer who lacks additional manpower doesn't realize how he's hurting his future business. He may think he can survive by himself, but it won't take an especially bright customer long in determining that additional manpower is needed. A customer will play "assistant" only so long, and then he'll hire a studio who has extra help the next time a similar job comes along. After all, it hardly becomes one's ego to be a stand-in for a *grunt*.

Going a step further, the studios that have the most assistants usually command and *get* the top dollar jobs.

Having described commercial photography, one can begin to realize that a lot of money is required to own and operate such a studio. It is not the run-of-the-mill business that is opened overnight. It would be a foolhardy photographer indeed who decided one day to open such a studio without original accounts that had pledged to sustain his early effort. Unless one has personal wealth to finance such a venture (and be able to sustain a possible business failure), such an approach to commercial photography should be dismissed.

The attractive feature of commercial photography is the sheer challenge of shooting so many different kinds

of things. It is never boring and has a high rate of satisfaction among its practitioners.

Opening one's own studio is not necessarily the answer, however, to becoming the complete photographer. Oftentimes, one is better off working for a studio that offers good pay, comfortable working conditions and challenging assignments. More than enough photographers have tried to create similar situations by self-employment and discovered that, if the fretting about new business didn't ulcerate them, then the vast amount of equipment and paperwork did.

Usually a photographer will only entertain self-employment if he hasn't found security or happiness working for others. The symptoms are easy to detect. He's not shooting the kind of assignments he was promised; he's not paid what he believes to be commensurate with his money-producing abilities; personality clashes make working conditions intolerable.

For some photographers, the drive to open their own studios looms as an illusory goal - something to be achieved no matter what the consequences. The need to be one's own boss is such a compulsion with them that it would appear as if there were some kind of stigma attached to them if they didn't attempt it at one time or another in their lifetime.

It is patently obvious that nothing gauges a person's ability to survive on his own merit more than self-employment.

Problematic with entertaining a business venture is weighing the consequences of failure, especially from a monetary standpoint. A new photographic business can require a lot of capital to get started, and oftentimes it is borrowed money. If the venture goes under, the borrower can spend quite a few years paying off the remaining debt. This can be quite a setback to one's

career financially, but sobering to the extent that a fair estimate of one's talents has been rendered.

By working for a studio and keeping a keen eye on the operations from the customer treatment to the paperwork, the photographer desiring to set up his own business will have some kind of expertise in adapting to the requirements of self-employment. Having become familiar with the various accounts and customers that give business to his present employer, the photographer has discovered the potential sources of revenue for his new business.

The neophyte businessman knows which accounts may be borderline customers and also the market to attack. This is of tremendous importance. Where to find new customers is an essential ingredient in launching any new business. In many circumstances, a photographer working for a studio gets to know a customer so well and has such an enviable rapport with him that the cameraman could claim the account for himself if trying self-employment, or use the customer's patronage as a plum to get a better job at another studio. Either way, such a situation has gotten countless photographers new employers or new business.

Disgruntled employers who have undergone such experience with an employee ought not hold a grudge. If they cannot compete legitimately with ex-employees, then the message of their ability has become transparent to the people in the trade. The wise photographer will always hire someone smarter than himself and pay him commensurately to keep him happy and increase *both* of their incomes.

A note to employers on ex-employees who have left them or been terminated with some prejudice: Don't bad-mouth them. Invariably it will backfire, somehow, and you or your studio will suffer from the unfavorable

remark which might or might not be true. It's the old sour grape syndrome come home to roost.

If one decides to open a commercial photo studio by purchasing an existing establishment from another photographer, beware of paying too much for the privilege of taking the plunge. It is common knowledge among commercial photographers that their customers deal with them personally because of *them*, not because they *work* for the XYZ Studio. Customers deal with certain photographers because of personal relationships built up over the years. Customers usually do not take up easily with a fresh face on the scene and enjoy the same rapport that they had with their regular photographer. Hence, when one buys such a studio, he should pay only a reasonable price for land and building and the same for any equipment that might come with it. Unlike a wedding and portrait studio, the commercial photographer has to get out on the streets and peddle his talent. If such a commercial man sits back in his studio to await his fortunes, it won't be long until he's trying to sell the same studio to a more ambitious soul.

The exception to this *caveat* is if the purchaser is buying the studio from his employer. In this case, the photographer has to concede that a certain amount of continued business will be forthcoming. Also, such change in management will probably not be so radical as to show a marked dropoff in revenue.

Usually the purchase price of such an arrangement should be nominal at best besides having to cough up sufficient funds for the tangible assets of a studio. Most employers who sell out to a faithful employee are compassionate enough to consider years of faithful service compensation enough for passing on whatever residual business that studio may enjoy.

As a postscript to buying a commercial studio, it is courting disaster to make such a transaction if the

photographer himself doesn't have a good background or experience in the world of commercial photography.

To the photographer looking for a new job or another position with a commercial studio, beware if there is a high rate of employee turnover. Usually a liability lurks somewhere beneath the icing when a studio can't keep cameramen. There are many employers who have extreme difficulty getting along with their employees or associates. The reasons can range from employee superiority to inherent distrust of other people. Some photographers have an absolute knack for alienating anyone who works for them simply because of an ego problem. They will talk down to their employees as if they were social and mental inferiors and untactfully order them around like a drill sergeant. The best advice when looking for a new job is to know something about the potential employer before accepting a position with him.

Not all established photographers take on neophytes to the business. Some cameramen expect their assistants to be fairly accomplished technically. It is the natural tendency for a photographer seeking better employment to land a job at a studio where he can learn from a master. Oftentimes in doing so, he overestimates his abilities and past experiences to the employer and discovers all too soon that he is inadequate for the job. Of course, the employer is aware of this much sooner, and a difficult condition then must be resolved, usually to the chagrin of the employee.

It behooves the photo trainee or photographer seeking a better job to level with the employer as to his abilities to avoid the inevitable mutual disappointments and disagreements that can occur if one's qualifications are misrepresented.

Few people entering photography know which field of photo work in which they would like to specialize. That they must make a selection of a specific field is not always

necessary. For example, if one is a photographer in a small town, he will find that his work probably combines portraiture with some commercial photography. perhaps some publicity photos as well as insurance and news work. Generally speaking, the small town photographer realizes that he must provide all types of photographic services to sustain himself financially, let alone show growth.

To achieve a good background in photography utilizing on the job training (OJT), it is best for the photographic aspirant to work for a number of studios, staying only long enough to absorb and digest whatever the employing studio has to offer. This can be difficult if one is in a small city and would require some relocation, temporary or otherwise, to achieve same.

In a large city, it is better for a cameraman to limit his business to a certain type of photography in which he has expertise. The reason for this should be self-evident inasmuch as the potential clients for his style of work are manifold in a teeming metropolis. Photographers in big cities who attempt to provide all kinds of photographic services usually end up with a haphazard reputation. Advertising agencies and corporation clients have a tendency to classify photographers according to specialties, and when a cameraman doesn't have a particularly outstanding strength, he is generally forgotten. By limiting one's trade to a specific kind of photography, the commercial photographer has a better chance of getting more desirable work from new and old customers.

Successful photographers have learned to develop a particular style, much in the same way that an orchestra can be identified by its "sound," a couturier by his designs, and an artist by his strokes. Large, in-city studios invariably can be identified by their "look," especially if they're heavy into consumer or industrial

advertising. On occasion, a photographer can conceive a specific type of mood photo, sell the picture and the idea to an advertising account, and launch himself on a successful and famous career. A Karsh portrait is instantly recognizable as is a d'Arazian industrial skyline. An Avedon fashion pic or an Irving Penn *anything* is easily identifiable.

Commercial photography is unlike most other branches of the business because the aspect of selling plays such an important role in achieving a modicum of success. The broad spectrum of potential customers also makes it the most interesting and fulfilling of the various fields of photography. Because of the manifold technical and artistic challenges that greet the commercial man every day, this kind of career carries a wide appeal to those whose lives are intensely fascinated by professional photography.

Free Lance Photography

The term 'free-lance photographer' has a ring of dash, sophistication, adventure, and desirability to just about everyone except the professional photographer. To the pro, the term means amateur, dilettante, neophyte, and pseudo professional . . . and is avoided as a label of his profession. It also has the disadvantage of casting a questionable shroud on one's credit when new in the trade.

Photographers prefer to be identified with the typical subject matter with which they are dealing. For example, if a photographer shoots mostly apparel, he labels himself a fashion photographer. If he shoots picture stories, he is a photojournalist. If he shoots photos used for advertising media, he calls himself an illustrative photographer. Actually, there are photographers who survive (and some do exceptionally well) by shooting single photos, picture stories, and/or series of shots on nothing but speculation. They then submit them to various sources for possible sale. In this sense, these photographers are truly free lance. Companies that buy these photos are listed in books designed solely for the purpose of informing aspiring photographers and writers where to sell their material. Such an example would be PHOTOGRAPHY MARKET PLACE (published by R.R. Bowker Co., 1180 Avenue of the Americas, New York, New York 10036) and WRITERS MARKET (published by Writer's Digest, 9933 Alliance Road, Cincinnatti, Ohio 45242). These books can be purchased at just about any good book store or may be found in the neighborhood libraries. In addition to

categorizing the magazines and publications for unsolicited material, the books currently list the do's and don'ts for specific companies and in many cases, give the name of the pertinent editor to direct any correspondence. Complete addresses are also included as well as what remunerations to expect for accepted submissions. Most of these special manuals are updated annually.

Rates for various material differ widely depending on the circulation and popularity of a particular publication. High on the list for unusually good fees are the companies who produce calendars. As expected, the exceptionally high quality large size transparency submissions receive the fattest checks.

When scanning these trade volumes, the 'free lance' photographer is easily excited because he can visualize limitless opportunities to sell just about anything he wants to shoot. This excitement can be short lived when he begins receiving rejection notices. Sometimes there is added frustration when the original source material is not returned or comes back damaged. But this should not discourage the cameraman from continuing his efforts.

Many a superb color slide disappears somewhere in the mail, at an editor's desk, or just as a result of poor handling. Sending transparency duplicates isn't always the answer either because of the added expense of production and frequent poor quality rendition by the supply house.

When submitting material through the mails, utmost care in preparing the parcel is advised. Slides should be sent in protective sheets or plastic binding pages so that direct handling by fingers is minimal. As we all know, one little fingerprint on a slide is deadly to the film. If a black and white photograph is going to be returned and possibly re-used for another magazine

submission, insert it into a clear plastic sleeve so that it will receive minimal damage by handling in the mails and on the publisher's desk. *And by all means, enclose a stamped self-addressed envelope or mailing bag to ensure a safe return of photographic submissions!*

If a particular picture series is quite valuable, it might behoove the photographer to write or telephone the publication to verify genuine subject interest before risking the material through the mails and subsequent handling by the company to which it is sent. Most houses that buy speculative material are understanding of these queries and advise the source quickly of their opinion.

Submitting photographic stories to more than one publication at a time is not a good policy. Luck will have it that two or more companies will accept the stories, forward a check and start the photographs (and the copy, if any) into production only to find that the material submitted is not exclusively theirs and therefore unacceptable. Time wasted in production is costly to them and the free-lance photographer will be blackballed on their lists (and, who knows, some other lists too).

It is always a better policy to submit material to a single publication, wait for reaction, and then, if rejected, forward the material to a secondary source, etc. The photographer should keep a log or ledger on what photos were sent to whom, on what date, opinion received, and when returned. This method produces a track record for the photographer to follow and also follow up.

Keeping abreast of certain publications that appeal to the photographer for future submissions is paramount for maximum acceptance by that company. One can readily understand that a magazine is not about to buy photography of a particular topic when it

just published such a story or article with similar photos.

Another piece of advice to the photographer is to become acquainted with the style of a particular buyer before submitting material for purchase. Each magazine, periodical and/or publishing house has its own peculiar format and preferences. Knowing this beforehand, the photographer who produces pictures with a particular publishing house in mind can customize his approach of the subject matter to make it more appealing to the buyer.

Sometimes the photographer who is considering shooting a potentially exciting series on his own initiative and has the means readily available to execute it can query a magazine or other source as to their interest in reviewing what he will shoot. This way the cameraman will have more impetus in planning the assignment and stimulate his interest throughout the shooting. He may also get some helpful suggestions from the editor he contacted.

The initial results of sending unsolicited photographs to the above mentioned publishers are usually a constant stream of rejection letters or no answer at all. This is to be expected and just about everybody who attempts these submissions can corroborate the results with similar experiences. As the photographer becomes more selective in subsequent material submitted, acceptances will be forthcoming. Of course, they are never as frequent as one would prefer, but with patience and diligence on the part of the cameraman, they do arrive.

Owing to the 'free lance' nature of this kind of photography, it has much appeal to the young photographer. Unfortunately, it does not have immediate income of any substance or regularity, thus making it difficult to keep the wolf from the door. If the

photographer has financial reserves and confidence in his ability to withstand the initial wave of rejection letters, he might survive. Also confronting the photographer is the sporadic nature of the work and the lack of security during poor economic times.

Happily, there are enough people making a decent living on such photographic speculation. This kind of profession holds a particular attraction for the person who may have some physical condition or affliction that would not afford him an oportunity to make his living in a more conventional way. Quite a few people are able to take photographs within their own homes or nearby premises and sell them to publications dealing with do-it-yourself projects, handyman hints, cooking, knitting, home hobbies, etc. As mentioned before, the ability to write is an additional invaluable aid if one wishes to free-lance photography to magazines.

Stock picture houses in the large metropolitan cities are also a source of free-lance selling. The management of these establishments are always interested in certain types of photographs and will be happy to send the cameraman literature on the particular photos desired. An unusual photograph can often times be sold many times over with the photographer receiving a residual fee for every use of the picture. Something to keep in mind is that many publications and photographic stock houses sell picture and picture stories not only domestically, but also abroad. It is not unusual for a particularly interesting story to be sold many times over to various countries throughout the world.

The names, addresses and telephone numbers of the photographic stock houses, which are usually found only in the larger cities, can be located in the yellow page telephone advertising directory available at

the local telephone business office. New York, Philadelphia, Chicago and Los Angeles are prime cities for such stock houses.

Probably the most attractive feature of the free-lance mode of living is that the photographer doesn't have to maintain a high overhead or own elaborate equipment to earn money with his camera. Some successful free-lance photographers own nothing more than a complete 35mm camera outfit. They farm out all their processing and a few deal exclusively with color slides as their only product.

Included in the free-lance category is the photographer who attends pet shows, horse shows, etc. and makes his money by photographing these subjects about which he is personally knowledgeable. Different requirements of pet show photography are employed which would undoubtedly offend an illustrative purist. A particular photograph of a Schnauzer at peak attention can be picked apart graphically (lighting, composition, background, etc.) by another photographer but little does he know that this 'mediocre' picture may best depict the animal's assets — a definite selling point to the pet owner. Besides, this kind of photography is lucrative and requires few hours of actual photography, and cash is given with the order. Weekend and evening work is the order of the day, but the total manhours on the job are few and the monetary returns rewarding.

The successful free-lance photographer can work at his own pace. He can incorporate vacations along with his photographic production and altogether plan his schedule to suit his current interests.

Having proved his mettle in the business, the photographer becomes a source of extreme envy by his friends and associates. Once established in the free-lance field, the cameraman or photojournalist can

anticipate a future of unparalleled choice and challenge with the assurance that once published, future security is almost always assured.

Ten

Photographic Salesmanship

No photographer likes to admit that he is a common salesman if only because the life of a salesman does not conjure up images of glamor or excitement. Most people think photographers lead fascinating lives, meet famous people, and in general, have the world on a string. In many cases, this is true. However, for a photographer to reach this plateau, one characteristic feature of his personality must surface early in his career. And that is his ability to get along with EVERYBODY. Call it charm, charisma, or whatever you like, but to be blunt, it is called salesmanship.

Salesmanship is knowing when to talk, what to talk about, when to listen, and in particular, making your customer think you are the most remarkable person he has ever met. And the most fascinating.

A major failure of many photographers to reach success is their egos. Granted, self-confidence is necessary for success. However, most photographers have an inflated estimate of their talent. They seem to be able to talk about nothing except their photos, their work, their awards and national recognition. If you don't believe me, just attend any professional organization meeting held by photographers. Anybody with their ears cocked will not be disappointed to hear occasional words of self-flattery that the large majority of cameramen indulge in.

As we all know, nothing is more tedious than listening to some fatuous egotist extolling his talents and drowning his audience in the drivel of his self-esteem. Trying to convince people of one's own

superiority by telling his listeners just how marvelous he is is the perfect path to alienation.

Very few potential customers to the photographer are necessarily swept off their feet simply by the photographer's portfolio. One can be the world's best photographic illustrator and yet be a professional flop if he cannot communicate in an interesting and personable manner. If one has difficulty conversing with a potential customer, the client will probably not have confidence in using this particular cameraman because he feels uneasy with the guy. Too, if a client has an out-of-town assignment, he doesn't want a social dullard traveling with him, beating his ear with stupid trivia at each lull in the conversation.

Too many professionals have yet to realize that their clientele don't always need the best photographer for every job. More often than not, a mediocre photographer walks off with the two-week out-of-town assignment because he is a good traveling companion, conversationalist, and can discuss just about any topic anybody can mention . . . and without becoming argumentative or disagreeable. Of course to be this photographic Dale Carnegie, the cameraman has to develop an interest in a myriad of subjects. He has to be abreast of current events, should be historically minded, a hobbyist of sorts, and have an active sense of what is going on in the art world. Since the photographer is dealing with an art form, it behooves him to closely follow artistic trends.

The importance of this last sentence cannot be stressed enough. A songwriter who isn't cognizant of contemporary music and the trends of the trade is less likely to be published than one who is. Similarly, a photographer who is not up on the latest graphic trends and nuances has to be the loser for this ignorance. God help the patients of a doctor whose medical knowledge has not kept up with the latest

methods and medications.

It is just this kind of graphic similarity in which the photographer who has a college degree can show his superiority. He has had the benefit of an in-depth education and at the same time gotten a good foundation in his trade. Having been exposed to higher education, he can converse on the same level with his most sophisiticated customers. If the photographer is leaning toward the illustrative or industrial advertising field, a college education is advisable since most of the people he will be communicating and working with will be products of higher education. This in itself sounds fatuous, but there is that indefinable benefit of self confidence that seems to come from having the same educational level (if not higher) as that of one's customers.

The public, in general, does not expect a photographer to have a college background. When one does, it usually has an advantageous effect on his career because it indicates he is probably premier in his business. A college education is also a very good entree to certain clientele that one might have known while in school. Since the college graduate usually ends up in the business world, friends and acquaintances of college days provide a ready-made roster of potential sources of income. Such social connections should not be overlooked when one is going about procuring new business. Keeping up with alumni news can reveal key information on the various career changes of old buddies and longtime friends.

Drumming up trade for a new business is a real concern for the cameraman. Some photographers simply can't bring themselves to knock on doors to get business. In this circumstance, they should try to team up with another person who doesn't mind selling. While one handles the securing of new business, the

other can concentrate on the more mechanical and mundane aspects of the new association.

This is not the healthiest way to operate a business. Close customer contact is an essential ingredient to bring off most particular assignments. The customer invariably wants to know something about the cameraman if only to satisfy minor things about the job. Can the photographer handle an intelligent conversation? Does he exude confidence in his ability? Could he possibly manage an assignment by himself? Does he have the experience and background to be charged with an important picture? Would he be attired properly and does he communicate well?

Avoiding person to person customer contact is undesirable for the photographer fresh in the business. The man behind the camera has got to develop a personal sales confidence in order to complement his photographic abilities. Oftentimes, a commercial photographer, with natural born selling ability, finds himself doing nothing but customer contact work. His knowledge of photography can make himself a handsome living just doing the liaison work between studio and customer. A select number of photographers choose to do this kind of customer relations exclusively. Occasionally, a cameraman who can "talk a good picture," but is unable to mechanically produce a photo as stellar as his prediction, realizes that his abilities in customer contact are a very salable commodity.

In large metropolitan cities, such photographers' representatives can make a bundle of money. By toting around a number of different first-rate photographers' portfolios and showing them to potential customers, the "rep" gives exposure to the photographers' latest work. He also provides himself with a high commission on any assignments he might be able to garner for any

one of them which he features. The photographic representative can also serve as an impetus for the photographer to shoot imaginative and unusual pictures, knowing that they will be viewed and evaluated by the type of customer he is trying to reach. This kind of liaison permits the photographer more time to experiment on his own without the worry of wondering where his next buck is coming from.

Making the transition from shooting photographer to representing them as a salesman is not a difficult switch to make in one's career. There are certain criteria to follow to insure getting off on the right foot. One should select only the top photographers in the area, and approach them with a written agreement to sell their work for a set commission, usually 20 to 25%. The representative can start his own business with no capital investment — just his magnetic, charming personality and a thorough knowledge of the technical aspects of photography as his forte. A natural desire for meeting people and socializing is an absolute *must* for achieving success in this business. He must be careful not to peddle second rate material in his quest to make a big buck. It is advisable not to represent two or more photographers whose work is very similar. Such representation can get him in dutch with the photographers who might suspect him of favoritism. With a portfolio of different photographers with different styles or specialties, the photo rep can assure himself better relations with his studios. Receptions at different art markets will also be easier as advertising managers and art directors seek out the new and the unusual.

The photographer's rep must also have an unerring eye and ear to know who is giving out what jobs. He must sift the phony big deal a customer promises from

the genuine assignments proffered by responsible clients. Thrown into the world of tight competition, the photographer's rep learns the restaurants and bistros to frequent, which companies and agencies to approach, and at what time of day. Like a reporter, a rep's contacts become invaluable; they also take time to accumulate.

Again, the importance here is for the rep to be careful to represent only the *best* photographers. Obviously, a salesman selling second class material is not in a prime position to get first class fees for his clients back at the studio. And, since the commissions vary in direct relationship to the assignment fees, it behooves the representative salesman to try for the big buck.

Being new to selling and having to approach unfamiliar clients has certain drawbacks. It takes time to find and ferret out those potential customers who actually do use photography. The first few months, possibly years, can be frustrating until this selling sense is developed. It takes time to develop a reputation and a rapport with customers. An art director or an advertising executive isn't about to give out an expensive or an important assignment to a Johnny-come-lately. Too much is at stake. The buyer has to have complete confidence in the photographer or his rep before doling out jobs to him. There are a number of ways to quickly instill mutual confidence between the buyer and the salesman.

To get one's foot in the door of a potential new customer (and also to keep an old client), try to meet him or her over lunch. The very casualness of sharing a meal with a potential client offers the rep an opportunity to chat about any number of things. It removes the "on stage" feeling that the salesman usually experiences when confronting his customer

from across his desk. By observing each other's manners and viewing likes and dislikes over lunch, both parties can absorb a better impression of each other (hopefully a favorable one). There are very few people who dislike having their lunch or dinner bought for them by a supplier. And, believe it or not, subconsciously or otherwise, the customer retains an obligation to return the favor. The result is invariably business. Granted, daily luncheon meetings with new or old customers can get pretty expensive, but the business generated by such personal contacts usually justifies the amount expended. It's the old bit of spending a buck to make a buck.

The significance of the above is that you, the rep, you the photographer, you, the aspiring salesman have to buy the meal, drink or whatever the purchase. Business is at stake. Since you are picking up the tab, you have the freedom, if not the license, to talk about anything you want. There is a tacit understanding that the customer, as your guest, permits you to broach any subject you please. You, the salesman, photographer or rep, have the golden opportunity to discuss anything you think will improve your chances of getting business. In the client's office, the shoe is on the other foot.

There is nothing more deadly to any salesman, or photographer than to develop a reputation for parsimony. Word spreads like wildfire when a cameraman is discovered to be "cheap." It is positively confounding to understand how a photographer on the verge of getting a super assignment can let a restaurant or bar check lie unattended on the table when presented for payment in the presence of a client. Too many assignments have been lost by photographers not savvy enough to pick up a customer's tab. And picking up the check does not

mean after it has been laying on the table or bar for an embarrassingly long time. The bill should never even reach the table. It should be quickly taken from the waiter or waitress, checked for accuracy and then paid. Having the fastest wallet in the West never hurt anybody's reputation.

There are some clients who are invariably too busy to share lunch with the photographer and will say as much soon enough. But they do appreciate the offer and it is not forgotten. In this case, the visiting photographer/salesman should be forewarned not to take up too much of his potential customer's time. The appointment should be brief, succinct, and to the point. The customer will not forget the tender offer of a free lunch, and the photographer/rep has the added advantage of gaining points with his client for having done so.

Again, the business of photography is buying and selling, effecting a transaction to the mutual satisfaction of the customer and the supplier. The vehicle that makes all this possible is competent salesmanship, the most important ingredient any business must have to survive.

Part-Time Photography

It is generally accepted that if one derives more than fifty per cent of his income from a certain activity, he is considered a professional in that trade. Some people are borderline cases when part-time income sometimes eclipses what they may earn on another job. Photography is one of those hobbies that can generate itself into a semi-professional career. There are thousands of people who utilize their cameras to provide part-time income and it does contribute substantially to their earning.

Typical of this kind of photography is the cameraman who shoots weekend wedding pictures. By working one day a week on actual shooting and using the services of a mail-order photo lab that specializes in wedding packages, the photographer can earn good money. This type of part-time income usually leaves few weekends (Saturdays especially) for leisure, but if the photographer gears his life style to consider a weekend nothing more than a working day(s), the social adjustment is a little easier — for free time can be arranged to suit a job style.

Some kind of positive effort always has to be made to ensure any kind of part-time income. It does seem to happen in wedding photography that word of mouth comments will stir inquiries among the guests at a marriage. Some queries of the bridal party invariably uncover a potential source for future business (providing the photos are satisfactory).

A good way to start such a "wedding connection" is to introduce yourself around to the different bridal

shops and stores that cater to wedding trappings. Offering a bottle of champagne and some samples of your work to the manager doesn't hurt either. Since it will be his or her recommendation of your services to future brides, it behooves you, the photographer, to sell this person on your capabilities and generosity. And don't forget to reward that person with more champagne for every referral you get.

If the part-time photographer doesn't want the responsibility of the entire wedding package, he can hire himself out to other professional wedding studios for weekend work as a *candid* man. It is not uncommon for large studios to farm out their candid wedding photography to part-time camera hobbyists. The usual procedure is for the studio to furnish the film and a list of photos required.

The majority of weddings that employ a lot of pomp take place during the summer months. And on a given weekend, the professional wedding studio could possibly have a dozen weddings or more. Hence, the need for a good roster of part-time help.

With more and more leisure time to consume nowadays, people with photographic interests are beginning to realize added income by frequent use of their cameras and darkrooms. Working conditions improve daily and extra holidays creep into the calendar with each passing year. The additional free time that camera enthusiasts enjoy can easily be converted into cash. There are so many projects that beg to be photographed that one need not tax his mind too long just to dig up one or two. Take the do-it-yourself syndrome.

The photographic step-by-step procedure of how to-do-it-yourself activity is a natural part-time photo activity than can bring in extra monies. Teaming up with a part-time writer who needs illustrations for a

magazine article is easy enough to research. A simple advertisement in the personal column of a local newspaper can bring active response for such a need. The how-to-do-it pictorial illustration can be applied to a number of interests from flower pollination to laying brick driveways. It should graphically include a simple but complete demonstration of the activity illustrated. The pictures should embody all the required steps with the necessary implements in use to achieve the desired end result.

The picture series should be photographed in such a manner that an editor need only furnish little, if any, information below the step-by-step photos. A demonstration series that can be illustrated with four good pictures should not be expanded to more than required unless a particular detail is involved and needs clarification. A good example of this would be a particular recipe for baking bread requiring complex steps to achieve success.

The part-time photographer who would like to shoot this kind of activity and is anything but handy around the house or has no diversified interest in any hobby should not be discouraged. A neighbor or relative who possesses superior skills in anything from a hobby to a household interest can be a ready money source for the photographer's camera.

If the part-time cameraman would like to photograph a particular series and a writer is not available to take notes during the filming, the photographer should try to glean as much specific information about the assignment that is necessary to make an interesting picture story. He should take copious notes and ask as many pertinent questions that he feels would have an impact on the story. Having a fact sheet crammed with notes is usually sufficient material for a writer (part-time or otherwise) to piece together the activity and

portray it in an interesting and salable manner. Pictures accompanied by a written story have a higher rate of acceptance than just the photos rendered with a fact sheet.

Pet photography, especially the animal shows, rodeos, auto racing, sports events and industrial trade shows all offer the part-time photographer a good opportunity to realize a chunk of money.

Good photography of yachts around marinas is always in demand. The proud owner of any boat finds it very difficult to turn down a 16 x 20 color print of his pride and joy. The boat owner is particularly sensitive to the appearance of his craft and he is quite vulnerable to a color picture of his beauty in a magnificent setting with just possibly an elegant sunset in the background. And, of course, him in the foreground.

Industrial shows that concentrate on various company displays are always ripe for photos. On such occasions the management should be approached prior to haphazardly shooting the display area. By bartering some kind of financial or photographic premium in exchange for the exclusive right to photograph display booths, the photographer can nail down a nice piece of business. And he might even get an annual contract to shoot future conventions.

Hotels and convention centers are particularly good contacts for the part-time photographer. Conventions are usually scheduled Mondays through Wednesdays or Wednesdays through Fridays. Knowing a schedule beforehand allows the photographer to work possible shooting into his timetable. Evening work in such conditions can be exploited for those whose regular job requires standard hours.

Preparing a color slide show for a boys' or girls' camp, YMCA activity, or any other group that would

welcome good low-cost photography, is a good opportunity for the ambitious part-time photographer. Any non-profit charitable institution should be queried for photographic needs. The initial request might be negative, but work at some future date could very well result from such a pitch.

Insurance companies that sell liability policies for home and auto use photography frequently. Many times a simple personal request for business can bring an assignment. Insurance companies are very price-minded and service oriented. The consistency of availability of the photographer can be a tremendous selling point when contacting an insurance company for its pictorial needs.

A metropolitan newspaper, if approached with a good solid picture or story, will quite often purchase it outright. The magazine editor is the man to see since it is his decision to use or refuse certain photography. The part-time cameraman should not be discouraged by initial refusals. Sooner or later one of the submissions will be accepted and then the ice is broken for future work.

The omnipresent color postcard is a prime example of what can be done with part-time photography. Was there ever a hotel, motel, restaurant or resort that could resist buying a gorgeous shot of its structure for a postcard. Rarely. The picture postcard is a source of revenue for the leisure time camera bug as well as the full-time professional who travels around the world doing just that very thing.

Typically, the photographer shoots such subject matter on his own (or by permission from the management on a speculation basis). He then has a postcard-sized color print made and submits it to the potential customer with a price estimate for quantity prints. Such prices can be gotten from any large

71

printing company or from such postcard specialists as Dexter Press (West Nyack, New York) who produce nothing but color postcards in tremendous quantities. Obviously the large postcard companies will have better prices, but they also take longer to make than the smaller printing concerns.

The drawback of postcard work is that many manufacturers of them require prepayment. This can require quite a cash investment on the photographer's part, especially if the order is voluminous. This fee can sometimes be lessened if a customer is willing to pay a large portion of the costs with his order.

Photography of church groups has become popular in the recent past. An arrangement with the pastor or minister to share in the profits for church projects is usually inducement enough to get a favorable nod. Such photos, taken on an annual basis, also create an historical interest as the years pass. Is there any of us who aren't fascinated by the way we looked ten years ago?

Producing photographic pins for sale at fund-raising events, be they mini-street fairs, flea markets, or outdoor summer art shows, is another way of making extra money. Using Polaroid color photos and a device that transforms them into button pins can produce quick money at such events. These pin-making contraptions can be bought rather reasonably from manufacturers that advertise under business opportunities in monthly photographic magazines.

Aerial pictures pose another good market for the hobbyist (especially if he has his own plane). Very few companies and/or homeowners can refuse a nice enlargement of their premises. One method of obtaining orders for such photos is to call up the public relations director of a corporation and tell him that you're going to be taking aerial photos in the area of

his plant the next clear day (he doesn't have to know it might be a weekend). You can suggest that you'd be happy to shoot some angles of his plant at no cost, if he would be interested in seeing such photographs. If he says "yes," the sale is 90% made. By getting a list of similar customers, it will soon pay to hire a small plane to fly over such an area and snap the aerials. Single engine planes are fairly reasonable to rent, and usually the sale of one color enlargement is sufficient to pay for the air time.

Shooting pictures of little league teams, boy scout and girl scout groups, or any athletic groups in the neighborhood can be ready sources for extra cash. What father can resist an 8 x 10 blowup of his nine-year old quarterback?

Most professional football, baseball, and basketball teams have "photography days" set aside in their playing schedule to allow fans to snap away. An astute part-time hobbyist with a good imagination can have a field day shooting up a storm at these occasions. For example, if the photographer did nothing more than photograph closeups of the menacing eyes of selected football players, the photos would be marketable to a sports publication. An accompanying sheet with some identifying details should also be included.

Books on where to sell one's photography on thousands of different subject material can be bought at most book stores. Local libraries also carry copies of these publications and they are updated yearly to reflect the changes in the selling market place. (See FREE LANCE PHOTOGRAPHY selling markets.)

Twelve

Photofinishing

Commercial and custom photofinishing is a business that few photographically inclined persons consider seriously. But they should.

Since we can't all be legendary figures in the camera world, some of us who are blessed with exceptional technical skills in the processing end of the trade ought to specialize in it. Every photographer worth his salt should have a complete working knowledge of the darkroom and at least the ability to produce acceptable prints and transparencies. The truly great photographers were all master craftsmen not only with their cameras, but also in the photographic finishing processes. In fact, it is nigh on impossible ever to become a photographer of any magnitude unless the techniques of film processing and printing are totally mastered. The two credentials go hand in hand and are tandem essentials for greatness in the art.

Granted, there are no immortal processing names that posterity will remember. But it can be safely said that a large number of name photographers received their acclaim thanks to the ingenuity of their technical assistants - their well-paid technical assistants.

There are among us quite a few people in photography who could care less for the camera end of the trade. Their only interest is to produce exceptional prints and slides of challenging source material. They realize the role they play in the photographic business and consider expert photofinishing a key ingredient to any photographer's success or failure in business. Having exceptional talent to make excellent prints and transparencies day

after day is a rare ability and few photographers possess it. The smart cameraman realizes that if he can't make superlative prints in the darkroom, the obvious solution is to hire someone who can.

Some photofinishers are only motivated by the money produced by a mass business, and let enough be said that they mercifully cater only to amateur work. This kind of photofinishing is a cut-throat business of cranking out slipshod prints and slides of erratic quality, constantly changing the prices to battle the competition.

Providing a processing lab for professional photographers, though, is a different story. There are various types of photofinishers catering to just about any and all cameramen's needs from huge murals to setting type on a transparency. Usually these particular labs specialize in just one or two services. Unfortunately, the number of these processing houses are all too few, and worse yet is the condition that only the very large cities have the more specialized ones.

Because of the unglamorous nature of the business, photofinishing does not attract very many able darkroom technicians. And this is a sad condition because there is a crying need for such businesses. For the talented darkroom technician to acknowledge that his strength is in processing and film handling rather than shooting is a situation that few professionals consider and intelligently weigh. For some reason or other, everybody thinks of himself as a photographer first and a darkroom expert last.

There are untold numbers of professional photographers who would rather not be bothered by processing demands and seek out a reliable photographic laboratory to produce high quality prints, transparencies, and other photographic needs. And on a definite time schedule.

Good photofinishing takes time, patience, and up-to-date equipment. Photographers, in general, who shoot predominately on location, prefer using a reliable laboratory that renders quick film processing and quality printing at a reasonable price. Most shooting photographers don't like to be bothered by reprint orders from customers and are more interested in making their money on the shooting fees rather than the printing charges that accompany most assignments. However, they do like the gravy dollars that reprints can bring them. A photographer who can boast a good, reliable (repeat reliable) photo lab, has the best of two worlds. A conscientious, responsible photo lab with a retinue of first-rate customers can't help being a success.

When conditions are such that the photographer needs immediate control over darkroom processing (such as the illustrative studio cameraman), an in-house lab is absolutely essential. This is especially true of studios that shoot a great deal of color photographs. It is the nature of this kind of business that print making and laboratory technical processes be monitored constantly. Studios with such labs usually charge high prices for their work and can well afford to support a low volume color laboratory.

However, thousands of photographers who spend most of their working hours shooting location work or even portraits, for that matter, do use outside laboratory facilities. Some of these labs are top echelon in service and quality, and some of them are woefully bad. Some that charge ridiculously low prices take weeks, if not months, to complete orders. A few excellent labs that charge high prices take an appreciable amount of time to deliver orders. Very few photofinishers render high quality on a rush basis unless the management has geared the operation to

cater to such requirements. The highest prices are charged by the good labs and the lowest by the poorer ones. It all goes back to the saying that you only get what you pay for.

A professional photo lab that strictly adheres to quality control and good service has a ready made list of potential customers from the day it opens. Just about every company has had, at one time or another, a need for such a lab. Publicity and advertising departments of almost any business are always interested in new professional processing houses. These companies should be approached immediately by the lab newly in business. A mailing piece containing full information about services available along with a price list is all that is needed to begin such an enterprise. The piece of literature should be sent to just about every major business in town. The assistance of a direct mail house or someone with an advertising background should be utilized to prepare and distribute the mailing piece. The yellow page section of the telephone directory can provide a selection of such specialty houses if one doesn't have personal contacts in the trade.

Gathering customers for a recently opened processing lab should not be a problem for the entrepreneur who continually broadcasts the fact to local businesses, especially the public relations, advertising, engineering and research departments of a corporation. A periodic mailing piece of an updated price list is also recommended to keep one's lab always in the mind of the customer. Personal visits, as time permits, are recommended to demonstrate added interest in the account. Periodic telephone contact should also be employed to become (and stay) familiar with the customer. Taking an ad in a trade journal aimed at typical customers is another method of

expanding one's sphere of income.

It seems to be the tendency of the photofinishing trade to produce quality and service in the first few months of operation and then lapse into mediocrity with the rest of the nameless processing houses. If and when a new lab is flooded with work, the tendency is to crank it out as fast as possible, with sacrifices made along the way. A watchful eye on print and film quality should always be made during these peak periods because reputations can become shaky when quality is compromised to meet deadlines. A new lab, like a new restaurant, invariably has an initial burst of trade since the curiosity-seeking public wishes to discover just how good the lab is. One should be prepared to handle such a barrage, if it materializes.

To be successful as a professional photo lab, it is imperative to always maintain 1) superior quality and service, 2) contact with customers (present and potential), and 3) good rapport with skilled employees paid a decent wage. If any of these conditions are absent, the lab is already on its way out of business.

Obviously only highly trained darkroom employees can produce quality work. To get such people in one's employ, the salary has to be attractive - attractive enough also to motivate them. It is difficult to infuse incentive in a darkroom technician when working conditions are poor, equipment for efficient production marginal, and a salary bordering on a minimim wage. Too many darkroom technicians think of themselves as forgotten men. To some, the excitement of pulling a superior print from an ordinary negative is sufficient to provide a daily job challenge. Others need to be recognized or pampered in some manner so as to keep their spirits sharp and healthy. New equipment invariably provides an uplift to the employee. A considerate and sympathetic boss who isn't afraid to

praise a subordinate's work is also necessary to motivate one's working force.

When a photofinishing house ceases to search for new customers via sales representatives, telephone contacts, direct mail campaigns, etc., it cannot grow. It must constantly advertise its services and benefits to maintain business. Because today's companies have such a high rate of employee shifting and transfers, the customer personnel picture is forever changing. New faces in new jobs have got to be exposed to the photographic lab's services periodically. A scheduled timetable of advertising and mailings should be maintained to insure maximum contact with potential customers.

The professional photographers who use the full services of a reputable processing lab prefer to work with the ones that specialize in personal service. It is important to the cameraman to believe that his processing house has a vested interest in him and his success. After all, the lab man is the photographer's right arm when it comes to productivity. It behooves the processing man to make the photographer appear better than he is (and many do just that).

The list of photographers with impressive reputations can be traced right back to the man who handled the film processing and printing. And don't think for a minute that the photographers are unaware of this. It only makes good sense to a cameraman to stay with a lab that flatters his negatives with superlative prints or can accommodate his color film for customized processing.

Pricing services for the professional processing laboratory can be a ticklish situation. It is extremely difficult to start a first class lab and charge the highest prices in town right off the bat — even though the service rendered is worth it. Customers like to try a

new lab if it is competitively priced with what they've been buying. The message here is to begin with a competitive price list and work pricing up gradually as the clientele becomes convinced of the extraordinary service and photographic quality rendered them. When business is so hectic and frantic from too much demand, raising prices upgrades the lab and keeps the better customers. Hiring additional employees is not always the answer to handle ever increasing work loads. Trying to get top dollar for the service rendered is a better consideration.

A messenger service or an employee to pick up and deliver orders to and from the lab is advisable. Anything that facilitates a transaction will be a bonus to the customer. Pickups and deliveries from clients that do very little business with the lab should not be continued unless one can see a potential for larger orders. By all means favor customers who feed you a lot of business. Give them as much priority as you can to nail down a long-lasting association.

The use of a private delivery service might be considered, especially in large metropolitan cities. The reliability of the messenger and/or messenger service should be constantly monitored since such businesses, of necessity, have to hire low-paid help to remain competitive. The importance of the reliable messenger really comes home if one stops to consider that the film order being picked up could possibly represent thousands of dollars worth of on-location shooting of a subject that could never be photographed again. Bonded messengers would be ideal for exposed film pick-up, and such a service should be widely advertised and broadcast to the photo lab's customers.

Choosing a location for a photofinishing business is all-important. This is not a venture that one should operate out of the home basement unless peculiar

circumstances dictate it. Since most technical labs survive best when located near their customers, it is recommended that the photo lab base of operations be close to the companies it wishes to serve. Presumably, the downtown area of a large city would be a prime consideration for such a business. It should be in a location which could operate twenty-four hours a day, if necessary.

The photographic processing lab should also be convenient for customers who wish to drop off material at unconventional hours. Rush service is becoming more in demand and the clientele seem to weather the excess charges billed for such service. A premium rate for extraordinary service is good income and should be charged in proportion to the time needed to provide the service.

Operation of a custom photo lab calls for discretion in the use of chemicals and materials used to make the transparencies, prints or whatever is needed during normal production. Very few labs can afford the luxury of maintaining a dozen or so different film developers to truly customize a patron's needs. The same also applies to photographic enlarging paper and duplication films. Certain basic well-known materials should be used in the processing to maintain a high standard of consistency of the product. By keeping a work system as simple and efficient as the operation will allow, difficulties of operation will be minimized.

Finding employees who know their way around a photo lab and can consistently pump out superior work is rare. If the business is located in a small city, the choice of selection can be even more dismal. Just training a mediocre darkroom technician can take years. Even an exceptionally intelligent employee undergoing advanced printing and processing methods can take many months.

Technical courses are periodically given to laboratory technicians by photographic material manufacturers for a nominal cost. And some short courses, usually of a week's duration, are offered by professionals around the country throughout the year. Information on these courses can be had by contacting representatives of a local photographic supply house.

A spinoff of the professional custom photo-finishing business is the photography lab that caters only to problem negatives, problem slides, and anything that offers a severe challenge that the customer is unable to deal with himself. This kind of service comes high and the talent required to make the venture a success is almost impossible to find. Such a specialty shop can be worked out of a home basement. It can even be a one-man operation. Business would have to be solicited by telephone contact, direct mail advertising, and trying to have friendly local photographic suppliers spread the word about this "unusual" service.

Thirteen
Getting Started

Self-employment, for those few who attempt it in their lifetime, is always a sobering experience. The odds against success are overwhelming (seven out of ten new businesses fail in the first year of operation). If a photographer buys out a business, his chances of surviving are substantially better, assuming, of course, that there is no dramatic fiscal dip concurrent with his arrival on the scene. A portrait and wedding studio is a good example of this. Sometimes a drastic personality change can precipitate a business downturn.

The photographer who launches a business from scratch is well advised to begin as cheaply as he can. If a studio can be located at the photographer's home, the business should be operated from there. It should remain there until such time as the home base begins to hinder studio growth. The benefits of operating a business out of the home are many. Just the tax savings and depreciation alone will warrant it. No long term lease is demanded, meals are convenient and cheap, and extra labor can be had if family is present. The immediate and constant drawback is not being able to get away from the office. Since one who is self-employed always has to labor long hours to accomplish some semblance of business continuity, he might as well be located where he can eat and sleep handily.

If the new business has one or more partners, a home location might have some drawbacks. Since photographic partnerships rarely last, the photographer contemplating self-employment should choose very carefully, if at all, that person or persons

that he wishes to affiliate himself with. Personality clashes usually scuttle a partnership, so the newly formed partners are advised to show great patience with each other.

Working out of one's home can be an absolute trial for the photographer's family, especially the spouse. Usually the lab(s) are in the basement, and the family room becomes a mini-studio or office. If the cameraman has children, the problem is worse. Their area of play is drastically reduced by the extra space needed for the business. This can take its toll, with tempers flaring at the restless kids trying to play in close surroundings. Children (and their friends) have a natural curiosity to poke around in anything that captures their interest, and photographic equipment and props can provide vulnerable targets. It takes a photographer a ton of discipline to keep his offspring at a safe distance to maintain an orderly, well-run home business.

Keeping one's mental equilibrium in a home studio is something that has to be worked at. Since the frustrations and temporary setbacks never leave the home office, they will invariably wreak social havoc every so often. Even a strong marriage can be subjected to bad moments that oftentimes leave the future uncertain. Mentioning all these minus features in regard to the home studio is not meant to discourage the photographer starting a new business. It is presented here so that the new businessman can prepare himself in advance for the inevitable.

Starting in photography from scratch (no steady accounts to bank on from the outset) almost demands some kind of money reserves to make the launch successful. It is a tempting thought to run out and buy a lot of equipment that one thinks is necessary for survival. Restraint should be used on such an

inclination until more thought is given its importance. Some self-employed photographers have borrowed money to start their businesses and lived to regret it. Others have done likewise and made it. It is difficult to make an assessment because each individual and his approach to business is so vastly different. One thing is sure. It is inadvisable to take a loan unless it is absolutely necessary. If an assignment hinges on having a piece of equipment which the photographer does not have, it shouldn't be purchased unless the amount for the equipment can be recovered by the job cost.

If the condition for self-employment success requires opening an office or studio in other than one's residence, some cautions are advised. When selecting a studio location or base of operations, the photographer should check to ensure that area offers a good degree of security for his equipment. The electrical wiring should provide enough power to handle the high wattage demands of tungsten lighting. The ceiling should be extraordinarily high to accommodate studio setups and large equipment.

If the studio or office cannot be on the first floor of a building, the cameraman should check the mode of transportation for large and heavy items to the studio and the availability of a freight elevator. Also, determination should be made as to the 24-hour availability of building utilities. Some offices turn the heat and air conditioning off over the weekends and also on holidays. Others do not permit visitors other than bonafide building lessees. Such potential conditions should be investigated before signing a lease.

In the large metropolitan areas where studios are indeed scarce, several photographers who are self-employed may agree to share the same studio and

sometimes even lab facilities. This can be an ideal situation for many because no one photographer has to ante up enormous overhead costs. Studio equipment can also be purchased on a shared basis and vulnerability to theft and break-ins is lessened. Studio space is invariably expensive. And what's more is that which is affordable is usually in an old building awaiting inevitable condemnation and demolition. Leases can also be problematical depending on the realty company or owner handling the terms.

Sometimes the intelligent direction the self-employed can take is to work out of one's residence for a few years and save enough money to erect an office/studio to his liking or design. This notion may seem unrealistic and demanding, but many a photographer has done just that.

The photographer who plans to do nothing but location shooting on a day, week or month-long basis is always better off working out of his home. Of course, one rarely begins self-employment with this kind of business awaiting him immediately. The assignments given to the recently self-employed seeking new clients are usually of such non-descript variety as to determine the scope of the photographer. Once the abilities of the cameraman have been established, the assignments are given in accordance with the talent of the photographer.

An advantage of a first-floor studio in a metropolitan area is the walk-in trade that it stimulates. Only certain kinds of photographers can benefit from this (portrait, passport, graphic arts, some types of commercial work). The first floor location with a show window gives the photographer an advertising area in which to attract new business. A few dazzling photographs in the window changed monthly can do wonders for the studio, especially

if it is located in a high traffic area.

Along with initiating a new business should be a visit to an accountant to set up the bookkeeping properly and keep the paperwork as simple as possible. Since this end of the business is usually the most distasteful part of self-employment, a local Certified Public Accountant should be consulted at the outset. It is bad enough to worry about the future of the photographic venture, let alone be staggered by the mountain of paper work required to satisfy local and federal regulations.

The question of whether to incorporate or be a sole proprietor should also be investigated with the accountant. Normally the entrepreneur in photography is either sole owner or a partner. Personal financial circumstances can change the choice, however, and the advice of a book-keeper should be sought. If the new business is a partnership, a buy-and-sell agreement should be drawn up immediately to protect the partners. An attorney should be consulted for such an agreement to tailor the terms to the people involved.

The buy-and-sell agreement (which is usually funded by term insurance) is nothing more than a document that provides for the continuation of the business in the event that one or more of the partners dies or wishes to leave the organization. Since most partnerships are short-lived anyhow, the buy-and-sell agreement does provide for fair disposal of the assets of a business with the least amount of disagreeable haggling.

Photographers contemplating partnership in a business venture are well advised to anticipate many and sundry disagreements. If either partner has an ego problem out of control, the union should

not be made. Partnerships are like marriage — it is one hundred percent yielding by all partners concerned. Partners who do not have any respect for their associates are in deep trouble. Such an attitude indicates a serious flaw already seeded in the new business.

The tendency of partnerships is that rarely do the partners perform equal effort on behalf of the business. For one reason or another, this can become a bone of contention early in the new venture. Unless such problems can be resolved by intelligent discussion, the path of operation can be hindered and oftentimes result in a breakdown of the business deal.

A lot of advice is mentioned here about partnerships because of the natural tendency of photographers to team up and share the expense of a new venture. It also relieves some of the psychological pressure for having made such a move since two heads are usually better than one when groping for business security. A good working partnership can make a new studio a success story many times faster than an individual working at his own pace. By having a mutual base of operations with common overhead expenses, the cost of staying in business and meeting monthly financial commitments is minimized. Free time (an unusual commodity to the newly self-employed) is also more frequent when there is more than one to share assignments.

Partners are also able to be each other's assistants on jobs that require additional people. They can be part-time models, messengers, prop hunter, etc. Assignments (especially studio work) almost always require an assistant to move lights, position subjects, and generally check the setting for objectionable items that could ruin a photo. Having a piece of the business

also, the partner is more inclined to work long hours without complaining and will endure conditions that many an employee would not tolerate. And at no increase in pay either!

Fourteen

The Customer is the Commodity

For the photographer whose task it is to ferret out new business as well as maintaining present customers, one's method of operating must be variable as well as flexible. Advertising, which is beneficial to some professionals, i.e., portrait and wedding business, can be a foolish expense for others. Customers are lurking everywhere. Just a little common sense is needed to dig them up and just a little talent to capture their business. To uncover these new clients, nothing can compare to the personal approach.

The business of photography is similar to just about every other enterprise. As mentioned before, the basis is supply and demand. It involves a customer buying a service or product from a supplier. For a purchaser to buy something, he has to have had some kind of exposure to the product or service desired. If a photographer relies only on advertising, he can never be sure he is reaching the kind of clientele he wants. This condition indicates the necessity of direct contact. Direct contact can be made either through a mailing piece sent to the attention of the pertinent individual or it can be made by the photographer in a personal visit or by telephone.

Relying on the postal service to deliver one's message or request is second best when it comes to initial contact sales. Too many things can go wrong. The customer's secretary might discard it as not being important enough for a second glance. The message could get lost, or the buyer, already swamped with paperwork, could throw it away if he didn't have time

to scan his mail.

Nothing beats the personal approach to sales. It is an opportunity for the client to meet the photographer and arrive at a quick estimation of his potential. Of course, the cameraman also gets a chance to evaluate his customer and discover just how discerning an individual he is. The most auspicious thing about a new client is the initial approach of the contact. First impressions are usually lasting ones. So a favorable meeting is to be recommended. The contact should be arranged at the convenience of the customer, when possible, to ensure at least some harmony in the timetable of the client's calendar.

Telephone fright on a cold call to a new customer is commonplace because the caller is always unsure of his reception by the answering party. One is never sure exactly of the state of mind of the person answering a phone. He could have just spilled something on his desk. Or maybe his boss has just called him on the carpet for a mistake. A family problem could just possibly be bugging him. The photographer making such cold calls should keep this in mind. A good policy is to make believe that everyone likes short telephone calls. By keeping the message brief and to the point, the salesman will automatically gain the initial favor of a customer if he is anyway interested in the sales pitch.

Some salesmen just can't bring themselves to forthrightly ask for an appointment to solicit business from the company being contacted. An honest, friendly attitude from the photographer to the customer to broach him about potential patronage is the best method of approach.

The customer contacted is usually pleasant. If he is unable to make an appointment with the salesman, he will usually tell him so outright. If a second contact to

the same man results in the same answer, don't pursue the customer further unless the account is large enough to warrant all that attention. If the customer is in another city and one is planning a sales visit to the area, send a letter ahead mentioning that a contact will be made upon arriving a certain day. Follow it up with a telephone call when in the area to reconfirm the appointment. Remember, the more opportunities of personal contact, the easier it is on the photographer when he makes the actual call.

Monday mornings and Friday afternoons are traditionally poor times to make customer sales calls. Last minute panics invariably crop up late Friday afternoon. Monday mornings are always bad news because of weekly planning sessions and meetings that are usually scheduled for that day. Also, many a Monday is needed to sober up after a partying weekend, particularly one that has a holiday included in it. Holiday seasons are also poor occasions to meet new prospects on the theory (and a good one) that a first great impression on the client might have dulled by the time the buyer gets around to ordering his photographic needs.

Most of the high-pressure salesmen with some measure of success will always insist on some kind of immediate business when meeting a customer for the first time. The reason for this is that all too often, for one reason or another, the buyer will forget about the salesman and his company upon his departure. An immediate order or assignment will cement a relationship on the spot, and make future calls easier on the photographic salesman. The high pressure approach for the photographer is definitely not recommended inasmuch as the client (and the cameraman) both realize that it takes time and patience to evaluate each other. A sense of urgency

for new business is almost enough for the client to back off and wait for a more suitable occasion.

Before a company or an individual is approached for photographic business, make sure that the right person is being approached with your sales pitch. For example, it is always better to see a creative director of an advertising agency first rather than his subordinate art directors. If the creative head is impressed with a photographer, he will make it his business to make sure that his subordinates meet the photographer also.

There is a method of selling that isn't exactly kosher, but is oftentimes effective. It entails determining one's sales contact at a company and then deliberately approaching *that man's supervisor* knowing full well that he will direct you to his subordinate. Armed with the instructions that the customer's boss suggested he deal with the photographer, the customer may feel that his superior wants him to do business with this particular photographer. Depending on the relationship of the boss to his subordinate, it can and has been a reliable method of getting new business.

Two of the best selling features most photographers can take advantage of are *service* and *quality*. And in that order. Service seems to be a forgotten commodity nowadays and many doors will open to the cameraman who can deliver on schedule. There are very few potential customers who aren't chronically plagued with tardy or delinquent service from their usual run-of-the-mill suppliers. Just about everybody is annoyed when a service or a product is not delivered on time. This uncertain condition always has an effect on future decisions on who or what company will get the sales. People have a tendency to buy from those suppliers who deliver on time. Cost can be a variable factor, but when the need arises, and the time-table is urgent, the salesman or the company that can produce on

schedule gets the order.

The only problem with promising prompt service is that the photographer has to fulfill his promise. If the photographic salesman fails on this score, his business is headed for trouble. Once a photographer's reliability is doubtful, no matter how talented he is, the customer will defer to the studio who can deliver by deadline. In some large studios, this feature of service is supervised by a particular person whose job consists entirely of ensuring that deliveries are made on time and to the proper person. Attention to detail is that feature upon which reputations are born and sustained.

Quality is the second salable feature. It is that extra something about an assignment or product that shows evidence of extreme care and diligence in fulfilling an order or request. It is that particular attention to detail that is usually found missing in routine work performed by average people.

Service and quality are easily rendered in any well-organized studio. If they become absolute goals for *everyone* on the photographic staff, getting new business will be a breeze, because word of mouth contact will help instead of making frequent business solicitations.

The list of companies requiring quick photo service is so large that photographers in medium size cities (100,000 population) should encounter no difficulty in locating customers. Insurance companies, news outlets (such as wire service or newspaper stringers), TV stations, publicity firms, or public relations departments of companies all need quickly taken photographs and speedy delivery.

Companies or individuals who need photos quickly are usually willing to sacrifice quality for speed. Quality and speed do not go hand in hand and the customer usually understands if the former is lacking. The logical

comparison is that a baby produced in seven months is possible, but it is more likely to have problems than a normal nine month term child.

Service is not totally confined to rapid, reliable delivery. It means attention to detail and full accommodation as contained in an assignment or directive. Service is not selfish. It should reflect a total willingness on the part of the supplier to give one hundred per cent of capability. It is that little extra touch that the client gets that he doesn't expect. It might be trivial and unimportant, but it reflects constant customer thoughtfulness by the photographer.

Once a new customer is brought into the business *family,* he should be carefully maintained by periodic visits, telephone calls, lunches, cocktails and perhaps an occasional weekend of golf or some such activity pertinent to his interest. The word 'family' is used to indicate that if one's customers are considered with familial concern and rapport, it is much easier to maintain a good working relationship with them. The best example of this closeness will be realized if and when the photographer has to announce a muffled job (heaven forbid!).

To keep the customer's interest in the cameraman and his studio, the photographer should attempt to keep an active mental file on the casual likes and dislikes of his patrons. Hobbies and sporting interests offer a lot of opportunities to make quick casual contacts on a friendly basis with the buyer. If a customer is really into antique glass, the photographer should be alert to whatever information he can get for him while visiting antique shops (even if he has to visit them only to furnish conversational tidbits to a contact). An afternoon of golf with a business foursome never wrecks a relationship (unless the 19th

95

hole becomes a drunken brawl). An evening at the races can cement a relationship, and empty a wallet.

Too many photographers consider such selling practices as prostituting themselves to obtain a decent livelihood. If this attitude is taken, the photographer has a definite marketing problem, and is well on his way toward the back of the pack. He'll end up being one more of the everyday horde of misbegotten photographers.

The old axiom of spending a buck to make a buck is all too true. It is nothing more than investing in oneself. Some customers expect the photographer/salesman to treat them regularly, but most don't. This is not to say, though, that just about every buyer, to a man, does not appreciate it. Traveling on a job with a customer offers the easiest way of dealing with this consideration. A simple first-class upgrade if traveling by plane is well remembered by the patron and a reasonable expense to boot.

Having the first wallet out of the pocket to pay for a taxi or a dinner check is always remembered even though payment of these might be made by other persons. Any photographer who can make his customers feel that working with him is an absolute pleasure can lock up that business for good — that is, assuming the photographs follow through with the impression.

A busy Chicago photographer who relies on a business representative to get him assignments can often disregard or forget the social and business niceties directed toward the customer. This can happen when a photographer isn't used to day-to-day selling habits. But this does not mean that the photographer shooting the assignment does not have to be diplomatic and pleasant with the client contacts. The cameraman should always maintain a friendly

disposition and a willingness to please the most testy of customers.

The *total* customer consideration approach applies only to those photographers who personally solicit business.

Observing the treatment given a client by a high-priced photographer will give some clue as to why he is high-priced and why the customer uses him. Obviously, if a client is given royal consideration and personal treatment in the studio or on location, the money must come from somewhere to afford such treatment. More often than not, the money spent for such pleasantries are incorporated in the price structure of the studio. Similarly, if the client expects an unusual photograph from the cameraman, the photographer must realize that it may call for an unusual scene or exotic props. This all costs money, and a lot of it. And the client knowingly pays for it.

The customer knows that he only gets what he pays for. The supplier knows this, and so does everyone else in the business world. The message should be loud and clear on finding and keeping new customers. Treat them like family. Make it easy and convenient for them to employ one's services. And treat *every* assignment and order as if future work depended *solely* on the last job. The self-destructive quality that can defeat this advice is an inflated ego on the part of the photographer. It must be kept in check to attract customers and *friends*.

Fiscal Responsibilities for the Self-Employed

Fiscal responsibility is nothing more than employing horse sense when buying or selling. As a self-employed photographer, it behooves one to buy supplies at the most reasonable price. Note the word *reasonable*. It does not necessarily mean the lowest price. Purchasing low price film that takes months to get is not a bargain if you need it next week. Rarely does a photographer (or anyone else, for that matter) find a photo supply house that ships merchandise the quickest and cheapest of any other competitor. It stands to reason that the store that keeps a huge inventory has to charge more for items than the smaller one who needs additional time to order from his wholesaler.

Having a good relationship with a supplier is invaluable, especially when emergencies arise. By keeping a close eye on inventory, the self-employed photographer can ensure that he doesn't have excessive amounts of money tied up in day-to-day supplies.

Huge amounts of money can be saved by simply buying good used photographic equipment. Stick with a recognized name brand. Make sure it is well-known enough to be repaired easily in other cities. It's not necessary that the equipment be in pristine condition. Scratches, scars, knicks and stains don't mean that the mechancial operation is bad. A quick check of the lens (visually) and a run-through of shutter speeds can readily assure the buyer of a camera's merit. Just

about any reputable photographic store will back up its merchandise, whether it's new or used. Granted, there are times when one has to buy new equipment (a revolutionary lens or emergency items), but generally speaking, don't buy new when you can find the same thing used — and at half the price.

God has yet to create the photographer who ever thought he had enough equipment. And, Lord knows, there are thousands more whose fragile businesses suffered from too much money being expended on equipment *at the wrong time.*

A good place to scour for used photo equipment is the want-ads of the large metropolitan daily newspapers. Don't forget to mention your needs, though, to your friendly neighborhood supply house. It can be an excellent source for bargains.

It can't hurt to know the local bank manager where you have your business account either. Cultivating his acquaintance and friendship can prove beneficial to your fledgling enterprise. Close connections with bank people can keep checks from bouncing (yes, it happens to the best of us, innocently or otherwise) and provide a ready access for future loans.

Bank managers make superb credit references. Familiarizing them with your potential can ease the red tape it takes oftentimes to secure short term notes. Too often we photographers come across a once-in-a-lifetime buy only to find our checking accounts bone dry. A short term loan can be the answer, and a friendly sympathetic loan officer can quickly cut through paper work to approve the money. And, who knows, maybe the bank needs some photographic work done.

Charging enough for one's photographic services is a chronic worry that just about every self-employed photographer frets about. Strangely enough, very few

cameramen fresh in the business bother to figure out mathematically what they should charge for their services. The usual practice is to find out what "other photographers" charge, and then do likewise. This policy is dangerous at best. Since most photographers think that they're the greatest thing since sliced bread, they automatically assume that they can charge the same as those *well-established* photographers. Such is not the case if only because the well-established photographer usually has rooms full of equipment and possibly some additional staff to help them.

Talent not withstanding, there is nothing more hazardous than pricing yourself beyond the capabilities of your equipment. It is a foolhardy photographer indeed who seeks out assignments that require equipment that he neither owns nor can rent.

The tendency of pricing nowadays is to establish a set photographic rate by the hour, the half-day, or the *per diem* rate. This is more applicable to the commercial, industrial, or advertising photographer than a wedding or portrait specialist. Usually film, prints, processing, mileage, etc. are charged separately and in addition to the service of photographer. It's a lot easier to explain this system of billing to a customer than drawing up a complicated schedule of charges. It also makes the accounting less time-consuming.

Establishing a price list depends, to a great extent, on one's overhead. Obviously the photographer who shoots only on location and has limited studio facilities, doesn't have to charge as much (if he doesn't want to, that is) as his competitors who may have large studios and more staff. Naturally, a good cameraman who has low prices will always find a market. The question is, are his prices high enough to sustain his new business?

Trial and error are the only guides one can offer at this juncture. Actually, it is the frequency of

assignments that dictates one's prices. The usual pattern is: the higher the price, the fewer the assignments. (But, also, the more free time to oneself).

It is no disgrace to be the lowest-priced photographer in town. Anybody bad-mouthing such a cameraman is simply expressing his own fears of being overpriced.

Before taking the leap of self-employment, the aspiring photographer should make a list of prospective expenses for one year's business. These items should include: utilities (heating, cooling, water, sewage, telephone and electrical bills); interest and mortgage payments; also auto expenses; real estate taxes; advertising; accounting expense; legal costs; office and miscellaneous monies. Included in this amount should be cash needed for day-to-day operational expense. Dividing the figure by twelve will make it easier to digest and less staggering to one's ambition. Add to this monthly figure any car payments, mortgage or rental money, and a realistic figure for food, clothing, and incidental expenses. If you are still sober after calculating this total, chances are you've got enough moxie to make your new business successful.

Particularly helpful is establishing a daily "bogey" for oneself. A *bogey* in this sense is the amount of money one must average every business day to keep his self-employment successful. There are roughly twenty business days a month or two hundred forty days a year. To find out what one's *bogey* is, the photographer should add up all his estimated expenses for the year and divide by two hundred and forty. Keeping a daily chart on the success or failure of making this *bogey* will keep you aware (painfully or otherwise) of your progress.

If the self-employed photographer finds himself on

the short side of earned income, it is advisable to either lengthen his work week or change his act.

The very fact that a photographer is recently self-employed can work to his advantage if he takes advantage of his newness. Admitting his situation to prospective customers can readily get him sympathy and some business from those clients who empathize with him. When one is new in the trade, he's smart enough to take anything he can get.

Fiscal responsibility will invariably determine the photographer's working schedule. If working sixteen hours a day is required to keep oneself abreast of debts, then that's what it takes. If the hours remain the same over a period of years and expenses remain static, something is wrong. The message here is: "Maybe you are one of those multitude of photographers that are better off working for others." It happens all the time and is hardly any cause for self-guilt. There are those of us who can't work for other people. But there are plenty more that find it better for their own physical and mental well-being.

When confronted by more bills than you have money, a general rule of thumb is to pay off as many small debts as you can and leave the big ones for special treatment. The theory behind this is to relieve the mental stress of a myriad of headaches and bolster yourself to tackle the main. Keep in mind that creditors usually show a deference to the delinquent customer who presents a positive attitude in paying off the debt. The invoice can be paid off in tardy installments without too much grief *as long as* the debtor does not dodge personal contact with the creditor. Granted, it's a tough task to handle such letters and phone calls. But consider it a personal challenge to your ability to convince such a creditor of your genuine desire to make good the full amount. In

doing so, your acting might just be overwhelming enough to inspire you to generate enough new business to pay the bill off sooner than you thought.

If the recently self-employed photographer is married and possibly with children, he should be duly careful of neglecting certain needs of his kids and especially his spouse. It behooves him to remember that sometimes it's better to bypass a new lens and buy something personal for his mate instead. Too often the concentration of business problems blinds the photographer from problems that crop up in the home out of simple neglect.

Fiscal responsibility extends into one's personal life as well as business associations. The two fit hand-in-glove. It's nigh on impossible to have one without the other. It is no small compliment to be the person about which some backhanded flatterer remarks, "I don't care what they say about the guy, he always paid his bills."

Sixteen
Photographic Specialties

Certain phases of photography appeal so much to some photographers that whole careers are devoted to a single kind of camera work.

Photographing rare museum pieces or archaeological artifacts is a fascinating full-time career where one can combine a love of the visual arts in conjunction with an avid interest in antiquity. Oftentimes the life styles are just as attractive as the work involved.

Just about every major university has a photographic department that functions as an integral part of its operations. By providing in-house photographic needs, the college is able to produce its own graphic arts requirements at reasonable fees. They frequently provide specialty photos for particular laboratory needs. The university photographer usually has such a wide range of requests that he very shortly becomes adept at shooting many sundry subjects. A training position under these circumstances can be an excellent entree to the photographic business.

Food photography is also a niche that is highly specialized. Aside from the fact that food is difficult to illustrate in an appetizing manner, the photographer has to have more than a working knowledge of proper background and decor. Also, he should be a competent cook in the event that he has to prepare a particular dish for shooting with all the appropriate garnishes that accompany the edible subject matter. In large cities, food stylists can be hired to do this very thing. They will, for a fee (expensive), cook and even arrange a particular foodstuff or recipe. However, the photographer who can prepare the photo from scratch

will come home with more 'honey.'

School portraiture is an enormous business. It is actually more business than photography since the photos (usually color) are cranked out like so much spaghetti. Poses are invariably static as long as the color tones are acceptable to the customers. The price is also competitively low since there are so many companies clamoring for these school contracts.

Lately, some traveling portrait businesses have discovered a measure of success by soliciting churches for "yearbook" souvenir photo albums. Their numbers have been increasing, indicating that this new source of revenue has been fruitful not only to them, but to the churches who get a healthy cut of the money.

Large metropolitan hospitals and university medical centers maintain photographic staffs to augment diagnostic departments and teaching aids. Macro and micro photography are daily routines even though, at times, some rather squeamish assignments arise. These jobs are not for faint-hearted photographers since many medical pictures test the physical durability of the most stoic cameraman. A large number of positions at institutions such as these are in the darkroom and the work can become boring if the subject matter is not challenging to the photographer.

Investigative photography appeals to a wide range of people. Police work, in particular, can offer excitement to the photographer who can withstand an occasional gruesome assignment or two that crop up. A particular desire to incorporate police work with photography has provided many a person with a fulfilling career with dual interests.

Just about every retail store that publishes a periodic catalogue has its own photographic department. And the wealth of experience a photographer can get quickly is indeed rare, especially

with those companies that market a full range of everyday items. The catalogue photographer, of necessity, has to be able to work quickly, yet effectively. The mental training of juggling two or three set-ups simultaneously and keeping their individuality from the vast amount of past and future merchandise is taxing indeed and difficult to master. A photographer who is ponderous in the studio will not last very long doing catalogue work.

Furniture manufacturers operate photographic facilities if only for the fact that very few commercial photographers have studios large enough to accommodate the mammoth room sets which they require to do justice to their products. Large format photography (4 x 5 & 8 x 10 view camera) is used at the furniture studios which are so gargantuan that they rival Hollywood in the sheer size of the building and the complexity of lighting equipment required.

Shooting pictures underwater does not seem to qualify as a specialty that would appeal to many people. Perhaps a lot of photographers believe that kind of business is severely limited because the availability of clientele is restricted. Because it is a field requiring unconventional camera apparatus, few cameramen bother with it. The ones that do have to be inordinately proficient with scuba gear let alone the complexities of the technical challenge involved from the photographic end of it. Again, this type of photography is obviously fascinating and would understandably make for an exciting lifestyle.

Just about every major baseball and football team employ staff photographers to provide publicity still photos and movie footage for their respective organizations. These jobs are not easy to come by. In fact, many of these positions are secured by free lance or news photographers who take it on their own to

shoot pictures of a team on a speculation basis and then show them to the organizations in the hope of a sale. By frequent contact with these clubs, the photographer gets to be known. And if his work is equal to their needs, they will approach him if a job becomes available (or if his work is consistently superior to the present photographer they employ).

As a photographer for a professional athletic team, considerable travel is involved and the work is somewhat seasonal. It is expected that the cameraman be athletically inclined or has a thorough working knowledge of the sport that he is photographing.

A big business, indeed, is banquet and convention photography. Usually a photographer will attempt to tie in his work to a major hotel or motel chain so that he will have ready access to incoming conventions. This kind of photography doesn't require an extensive knowledge of camera work. Much of it is, in fact, just straight, simple and somewhat tedious shooting. The working hours are invariably long with a large amount of evening assignments. But it can be a lucrative business and more than a few photographic firms vie for big convention contracts. Prices are usually predetermined with the group holding the convention, and the photographic services to be rendered are exclusive.

Convention photography is a business that an individual can easily get into without any great outlay of money and become instantly successful. Unfortunately, the subject matter becomes tiresome because of so much similarity. Hence it is not recommended for the photographer who needs imaginative challenges to sustain his interest in the field.

Trade shows at large convention plazas or civic centers also fall into this same category. The usual

method of acquiring exclusive photographic coverage at mammoth exhibitions is to contact the pertinent organization six to nine months prior to it's next big exposition and attempt to nail down a contract by offering some kind of attractive fringe benefit or some sort of financial rebate to the company involved.

Vacation resorts hire photographers to accommodate the thousands of guests that patronize their establishments. Sometimes the photographer is hired outright and sometimes the picture work is leased on a percentage basis (so much of the income goes to the photographer, and so much goes to the resort). Vacation camera work can be pleasant and the variety of subject matter quite interesting. Some of the more cushy watering spots can downright spoil a photographer, and the fascinating crossection of people provide a ready made social climate.

An extension of vacation photography is the ocean tour liners whose photographers seem to snap pictures of the passengers at every fall of the gangplank. It should be mentioned that each tour company negotiates different types of contract work with the photographer. Some shipping companies hire photographers as part and parcel of their everyday operations.

In the balmier parts of the world, where the affluent flock to their marinas, boat photography is a popular avocation for a few photo entrepreneurs. Fees charged are in proportion to the wealth, and there is hardly a yachtsman who can resist buying a large color print of himself with his floating home.

Animal shows offer an excellent opportunity for a truly specialized and unusual career. It is an absolute requirement for the photographer to have a good working knowledge of the animal(s) in order to capture the subject at its flattering best. Pet and animal shows

are usually scheduled on weekends and can be held at just about anywhere in the country with travel an integral part of the lifestyle. The fees are good and customer interest guaranteed because the only tangible visual evidence of honor, in addition to a possible ribbon, is a photograph of the winning pet or animal. Rarely does any animal owner refuse an offer of having his champion photographed for posterity. Breaking into this business does require substantial contacts in the field and a considerable knowledge of who's who in pet circles. A certain affinity for knowing when pet show photo contracts are up for grabs can be useful to the photographer who is resourceful enough to explore this field.

When one speaks of political photography he is indeed referring to that rarified air that many photographers aspire to, but few make. What is referred to here is not a common governmental job as one might think, but an occupation where the photographer's exclusive concern is to pictorially chronicle the daily lives of one or more important political personalities over a period of time. The word 'time' here refers to that period where the political figure(s)remains popular and incumbent. There is also a certain historical import attached to whatever pictures are rendered by the political cameraman. Because of the constant changing popularities among governmental leaders, the photographer finds himself challenged daily to record what could easily turn out to be epoch moments of history. Achieving this along with competently photographing one's employer in appealing pictures presents a formidable challenge that few photographers find easy.

Medical photographic departments are maintained by just about every major hospital in the world. The necessity to photograph everything from gross

specimens to microphotographic slides is part and parcel of daily hospital routine. Still and motion picture photography of unusual operating room and diagnostic procedures are always needed to document new research. And these processes occur daily at large municipal hospitals and university-associated medical centers.

Even though architectural photography is done by most commercial studios, it is an exacting enough business in itself to warrant singular treatment under the category of a photographic specialty. Understandably, there are only a handful of such studios across the country, and they have highly competent staffs. Suffice it to say that it takes a certain kind of photographer with an uncanny knowledge of design and composition to even *qualify* for one of the few openings that rarely become available.

Baby photography, or *kidnapping* as it is popularly known in the trade, is probably the most common specialty of the business. It is also one of the most hectic and competitive businesses in which to make a living. Most photographers who choose this way of living have some kind of an arrangement with maternity hospitals to photograph newborns and then followup photography as the infants grow older. Studios that hire photographers to shoot babies at their homes usually find the pace too demanding for the pay scale. It is not unusual to find huge turnover of these photographic staffs at studios that concentrate on this photographic specialty.

Information on the below listed photographic specialties can be gotten from the Eastman Kodak Company. Contact the nearest Company office in your area for further information.

Astropholography

Underwater Photography

Animal Photography
Flower Photography
Making a Movie
Nature Photography
Photomicrography
Tropical Photography
Arctic Photography
Television Photography
Medical Photography
Surveillance Photography
Police Photography
Clinical Photography
Photointerpretation
Scientific Photography
Cinephotomicrography
Portrait Technicians
Photography for the Graphic Arts

Most of these booklets cost a nominal sum. Also, this list represents a very small number of books and literature that exist on just about every phase and development of the world of photography.

Besides the Eastman Kodak Company are a number of other publishers prominent in producing photographic reference texts. They are:

Amphoto, Garden City, New Youk
Morgan & Morgan, Dobbs Ferry, New York
Arno Press, New York, New York
Little, Brown, Boston, Massachusetts
Doubleday, Garden City, New York
Prentice-Hall, Englewood Cliffs, New Jersey

Seventeen
Photography as a Woman's Career

Until recently, the number of women achieving fame in the world of art remained a token few. By now, we realize that a male dominated society has been responsible for this omission. Social customers and family prejudices have accounted for discouraging many women from pursuing a career, let alone a career in arts. It was almost as if some universal conspiracy existed to keep females out of the arts. The old hackneyed excuse was that women could never consistently create art objects that had the strength and feeling that their male counterparts could. Society now realizes its error.

Women have made sharp advances in just about every art-related career they've selected. And photography is a good example of this rise to fame.

The advent of the 35mm and small compact camera helped tremendously. Although a sizeable percentage of photos are taken with large bulky cameras and heavy lenses, an increasing percentage is being shot with small cameras. The appeal of these miniature lighweight cameras, combined with advances in film technology, has renewed an interest in the trade. And since the female clamor for equal rights is finally being heard by our legislators, jobs are opening up for the women which had previously been denied them. Photography is one of those businesses which wasn't directly affected by the equal rights laws, but was one of the careers that the liberated woman found much to her liking.

The predominant number of females select photojournalism because of the ease of the camera work, the interesting assignment, and the best chance to compete with men. Others became portrait photographers where the camera equipment, though bulky, is stationary. Few women bother to work in the commercial/industrial field because the physical requirements are often overwhelming for the physique of the female. It is easily understandable why a woman would make a poor blacksmith - the work required great physical strength which the average woman does not possess. Similarly, commercial and industrial photographers use weighty equipment almost daily, oftentimes to the point of exhaustion. Just about every photographer has to hump his own heavy bags around. Those few who refuse to do the lifting have to hire somebody to do it for them. It also follows that every dollar paid out to an assistant to perform a convenience task means money out of one's pocket.

Though the number of salaried women photographers is on the increase, self-employed female photographers have not kept pace with their sister infiltration of the business. This again can be traced to women being leery of competing directly with men in the male oriented trade. One can well understand why any woman would not want to beat her brains out trying to get work from a photographic buyer that is simply not accustomed to dealing with women. And, of course, bankers and financial lending institutions haven't helped, treating female loan applications with all the deference of leprosy - as classic a case of discrimination that ever existed on earth.

Male black photographers struggled for years even to get salaried jobs at low pay just to get into the business. Once, there, they realized that self-employment was almost out of the question for most

kinds of photographic work. Only the traditional jobs in the wedding and portrait field and news photography were open to them.

Women have eclipsed that phase of the prejudice by forcing their presence on the populace as a whole.

Part of the reason that women still have to battle uphill to achieve the measure of success that the male photographer has can be blamed on having to deal with the *artist temperament* - not theirs, but others. Throughout the ages, artists have not been very friendly toward other artists, especially if their styles clash. It was (and still is) the *artist temperament* to view another artist's work with doubt and suspicion as to its greatness. For a man to even consider a woman his artistic equal was out of the question. Prior to the middle 1800's, any woman who achieved even a modicum of artistic fame, earned it by some quirk of fate. For certainly, her male counterparts did nothing to educate or prepare her for a career as an artist. Not until Pittsburgh's expatriate painter, Mary Cassatt, appeared on the scene were women deemed talented enough to be compared with men on a world-wide basis.

Post World War II brought an enlightenment in family styles, mores, and educational challenges for both sexes. Women have seized on this era and have forced their proper place in world business. They still do battle with male prejudices in business matters, and photography is still the site of this battleground. Men do most of the photographic hiring and buying much to the chagrin of the female cameraperson.

Perhaps, because so many people that buy photographic art are men, their natural preference leans toward purchasing pictures from men. A similar analogy would be a man buying a suit, shirt or coat from a saleswoman. The man inherently distrusts a

woman's knowledge or judgement as to what looks right or wrong for him.

Women rarely set out on careers without some confidence that they will succeed. Usually this is because they have had some measure of success at what they're striving for. In the photographic world, there is immense uncertainty among those who try to make a go of it. Oftentimes, years of failure and/or mediocrity are a prelude to success in the field. That so many photographers muster the ability to hold on long enough for their business to take a toehold is a testimony as to the steadfastness and optimism needed to succeed in the field.

Women, on the other hand, have a tendency to avoid, if not abandon, a career that gives every appearance of an uphill struggle. Because photography careers are plagued with unknown factors, the security minded individual will search elsewhere for an avocation that poses an easier chance for success.

Because photography is not exactly a common trade, there are no known hard and fast methods for preparing oneself for a job, let alone finding one that is just what one is seeking. (It is hoped that this book will help rectify this condition).

Eighteen

Additional Considerations to Becoming a Successful Photographer

Knowing One's Limitations

Self evaluation is a practice that people seem reluctant to ponder. One of the successes in life is to know and realize the scope of one's talent, and then deal with this knowledge intelligently. It is a futile exercise developing a mental condition in trying to be what one can't be. Too many photographers simply can't accept the fact that their talents have definite limits and have to be dealt with intelligently. There is always that group of camera buffs who maintain that wealth and success have passed them by because some odd quirk of fate has kept them from making it big.

Too many photographers have a frustration complex because they haven't had the 'breaks.' The case is usually one where the cameraman consciously accepts the status quo and refuses to actively do anything about it. Without a positive effort made to improve one's situation, the frustrated photographer can become bitter and resentful, lapsing into mediocrity and blaming it on his personal bad luck.

Even with an active attempt to increase one's status in life and business, one's goals might be too ambitious and simply can't be attained because of personal limitations. It is a big person, indeed, who realizes this, takes the measure of his abilities and then proceeds through life with this knowledge as his guide.

Being able to live and work within the limits of

116

one's own abilities can't help but add to one's own mental health and personal satisfaction throughout life. It is only when one is unable to recognize the boundaries of his abilities that things go wrong. The sooner in life he is able to make this determination, the longer, happier life he'll enjoy.

Investing In Oneself

The photographer-businessman who is eagerly building up his bank account without reinvesting an adequate share in his company is headed for trouble. New equipment and materials that seem to emerge daily from different manufacturers serve notice that if one does not keep abreast of the times, the times will pass him by. Constant attention to innovation and improvement is a prime consideration in maintaining one's status and attracting new customers.

The same can be said for equipment maintenance. All too often a photographer tries to make do with camera, lights, etc., that may need minor repairs or are borderline cases for breakdowns. The photographer's treatment of his equipment should be similar to his own physical considerations. If one abuses his bodily needs, the body responds in proper fashion by manifesting these misdeeds with illness or something even more serious.

The constant parade of new items and photo equipment that arrive daily is almost too much to assimilate by casual glances at trade journals and/or various photographic publications. Attending periodic demonstrations of new equipment and exhibitions of the latest photographic devices can keep one aware of what's new in the field.

Occasionally some of the more aggressive photographic salesmen take it upon themselves to try to familiarize their customers with the new equipment

and products in their everyday contact with them. As good a practice as this is, today's professional should not wait to be told about such items but actively seek out those items that would help his professional image and his pocketbook.

Philosophy And Interests

The next best thing to innovation is imitation and the ability to cash in quickly on somebody else's great idea. Discovering trends early and employing them in one's ideas can be just the thing to keep a photographer's reputation up near the top. How often we've all seen a new dynamic angle or perspective used in a photograph or drawing, and then watched as all the imitators stepped in and copied variations on a theme of the original idea for years to come.

Since we all can't be international legends because of our own personal limitations, it behooves us to make the most with what we have. And if that limitation includes early recognition of a great idea, then exploiting that recognition should become our specialty. The adage of being not the first by which the new is tried, nor be the last to lay the old aside is a pertinent observation and wise advice in graphic arts. By staying abreast of current trends in photography design, one's customers develop a confidence in the photographer and come to rely on his judgement and advice.

The older one gets, the more important this idea of *contemporariness* or awareness of the times should be realized. It seems to be a national habit to label the older photographer as out of tune with the times. This is especially true of the portrait and advertising fields. The senior photographer has to be keenly aware that his longtime style and practices should be regularly infused with that which is new and exciting in the business and art world.

118

Perception

Being satisfied with arranging a particular single photograph and shooting just one perspective of it without considering (if not checking) another one is the mark of a true amateur. Just observing a crowd of camera-bedecked tourists gawking and snapping single pictures of the same old tired scenic sites should be example enough for the professional to avoid this worst of bad habits.

Just about every camera subject can be photographed in an infinite number of ways, each retaining a singular quality and appeal different from each other. Just the slightest change in lighting and composition can occasion yet another infinite variety of angles and perspectives. Using a full range of various lenses again injects yet more and more ways of rendering a particular subject on film. Being dissatisfied with one's initial concept of a photograph should become a professional photographer's second nature. Only by seeking out alternate approaches to a particular photo can a cameraman become adept at arriving at the best possible perspective, angle, lighting and lens with which to shoot a given picture.

Some of the larger photographic studios will combine the ideas and talents of several photographers on complex assignments to ensure that second-guessing by the customer after the picture has been taken is kept to a minimum. This is particularly important when a number of props are used and attention to background detail is required. And speaking of second guessing, this practice should be an everyday habit by every photographer BEFORE any picture is taken. A total re-examination of the pictorial needs requested by the customer or client should be mulled over before any final exposures are

made. The reason for this is because once the exposures are put on film, the photographer has a tendency to concentrate solely on the technical operations of the camera and film. The actual subject matter and its detail are somewhat neglected once the mechanics of exposure begin.

Having a second photographer or assistant on the scene is always helpful if only to scan the camera subject for possible faults before and during the exposures. By second guessing each photograph, the cameraman is keeping post-picture criticism to a minimum.

With every introduction of a dramatic new lens, especially wide angle and telephoto lenses, whole new perspectives are born for every subject to be photographed. These new perspectives are born for every subject to be photographed. These new perspectives are great selling points for the industrial and illustrative photographers, in particular, who literally survive on the new and unsual angle they can constantly show in their photographs.

Attitude

Attitude is the flexibility of a person to adapt to a situation and how he responds to it. Obviously, one who adapts easily to a challenge and is equal to a task, especially in photography, has one of the elements of a successful future. Attitude incorporates a mutual understanding and digestion of the needs of a customer or photo request.

As good as a photograph might be that a photographer shoots for a customer, if it does not graphically fulfill the special needs of the request, the picture is worthless. Too often the cameraman's ego comes into play and he shoots the picture 'his way' because he deemed it best that way, be it for esthetic

reasons or otherwise. By 'covering' oneself, that is, shooting a subject several ways, insuring that at least one version is just what the client suggested, the photographer's attitude will have surmounted possible problems later on.

Attitude is easily affected by outside forces that come into play for any number of reasons, some voluntary and others involuntary. Obviously, the less pressure on somebody, the better his mental and physical health stands to be. A photographer, approaching an important assignment, is well advised to maintain the optimum of coolness to insure maximum control and competence during the shooting session.

Too often, poor planning and last minute unnecessary rushing can adversely affect an assignment. Perhaps even a big night on the town prior to a job is just enough to undo a cameraman and bring about poor or mediocre results. Although some photographers seem to work well under some strain or duress, the reverse is more often the case. Personal conflicts, family or business associated, can dramatically affect one's attitude and performance. This kind of strife can't help but show up in the pictorial efforts of a photographer who is constantly afflicted with personal problems or doesn't know how to cope with them.

Attitude is also an important bellweather that customers use to evaluate and select a particular photographer for a specific job. As mentioned previously, no client wants to spend time around a photographer whose personality conflicts with his own, whether or not he is eminently capable of doing a bangup job on the pictures.

It is sufficient to say that one's healthy attitude toward work, customers or contacts, and sociability

121

among friends has a direct affect on one's personal success story.

Photography As A Professional Hobby

The great photographers who have dominated the pictorial world have approached camera work as a hobby that one works at on a full time basis. It was such a labor of love that their lives had a satisfaction that were and are the envy of thousands. When photography ceases to be a hobby and becomes plain unadulterated work, the cameraman begins to lose the edge that he usually maintains when his interest has total involvement.

A sometime problem that arises with *too much* photography is the little time left to explore other hobbies or interests. We all know how boring it is to talk with a person who can only discuss one or two subjects. We also know how fascinating the person with multiple interests can be.

Varied interests in life are usually a stimulant to sharpen one's awareness of what's going on around him. Just as a vacation serves to refresh one's mental and physical outlook, so does an assortment of interests keep one's mental outlook in perspective with the rest of the world.

Retrospect

The photographer seeking to reach success quickly in his profession should beware not to tarry too long in a job that is not part and parcel of his way in reaching that goal. The more varied one's exposure is to different fields of photography, the more flexible and adaptable he can be in the branch of photography one chooses for a livelihood. Having a good solid background in different phases of photography can equip one to more easily enter the other fields of the

trade, should he care to switch sometime during his career. Some fairly famous portraitists didn't specialize in portraiture until rather late in their careers. Some well-known industrial cameramen started out in other branches of the photographic business before concentrating solely on industrial pictorials.

Early determination of one's goal in life is to be recommended, especially in photography, where late choice of a career can be detrimental to acheiving one's avocation, let alone reaching a measure of success in it.

History has shown us that anyone who has demonstrated a precocity in any field, be it music, art, mathematics or whatever, that individual, if he pursues his particular interest, excells in it as long as his attention is captivated by it. Photography, though not considered a prime intellectual endeavor, does have its precocious few who are indeed famous and demonstrate a degree of mental luminosity that can compare with the famous names of this or any era.

Making the most of one's abilities in a particular field, and liking it to boot, is the yardstick of success in any business or lifestyle. Pursuing a career which produces a better income and level of achievement, yet wanting to succeed in another field that offers less advantages, is a struggle common to many. Sometimes the urge for inner happiness overcomes the agony of trying to succeed in a business that does not lend itself to mental and familial happiness. Recognizing this, and doing something about it, can be the most important action one does in his lifetime.

The photographic profession has a way of attracting thousands of people who would like to succeed in the business but find that the early going is too rough and too uncertain to pursue. It takes a person with single-minded conviction that he will be a success, no matter what, to reach the Parnassus of the profession.

INDEX